DRAWING THE HUMAN HEAD

Burne Hogarth
DRAWING THE HUMAN HEAD
by the author of Dynamic Anatomy

Watson-Guptill Publications/New York

Paperback Edition
First Printing 1989

Trademark BURNE HOGARTH™ and Trademark
DRAWING THE HUMAN HEAD™ are owned by
Burne Hogarth Dynamic Media Worldwide LLC
and used by Permission.

First published in 1965 in New York by Watson-Guptill Publications,
a division of VNU Business Media, Inc.,
770 Broadway, New York, NY 10003
www.wgpub.com

Library of Congress Catalog Card Number: 64-14763
ISBN 0-8230-1375-8
ISBN 0-8230-1376-6 (pbk)

Manufactured in U.S.A.

19 20 21 22 23 24 25 / 11 10 09 08 07 06 05

To my wife Constance;
to my children Richard
and Ross, Michael and Mary.
When these embers are reduced
to ashes, who finally will
know its warmth?
This is for them, after all.

Table
of
Contents

Introduction

Among all the subjects which the art student is called upon to draw, none is more complex than the human head. The head presents subtleties of form, structure, and proportion which are a continuing challenge not only to art students, but to professionals. To many, drawing the head is not merely a perpetual challenge, but a perpetual struggle.

Watching students wrestle with the problems of drawing the head for many years, I have long hoped to see a book which would take some of the guesswork out of their struggles: a book which would systematically assemble the basic facts that every artist needs to know in order to draw the head convincingly.

Drawing the Human Head fulfills this hope. Based on the author's widely respected drawing classes at the School of Visual Arts in New York, this is the most comprehensive book now available on this vital subject. The author does not pretend that this is the ultimate book on the human head. The ultimate book will never be written. After all, Rembrandt, the greatest of all portrait painters, was still discovering new insights about the human head in the final years of his life.

Drawing the Human Head is simply an attempt to organize basic information: systems of proportion, concepts of form, anatomical facts, and other data which have formed the basis of sound draftsmanship for more than 2000 years.

None of this material is radically new. On the contrary, this approach to drawing—this method of visualizing the human head, the human face, and its features—begins with

the artists of ancient Greece, reaches its greatest refinement in the Renaissance, and has been followed by artists and art teachers to the present day. The systems of proportions and concepts of form which are presented in *Drawing the Human Head* are essentially those which were perfected by the Greek sculptors. The anatomical information was first assembled by the artists of the Renaissance. Although modes of artistic expression change from one era to another, we are still building on the foundation laid by these remarkable men.

Drawing the Human Head begins with a definition of the major masses of the head—the cranial and facial masses—and demonstrates how to draw their shapes, contours, and proportions. Via drawings and diagrams, we then move closer to the individual structures that form the head: the forms of the skull and facial mass; the jaw; and the nine dominant facial features, from brow ridge to chin box.

We then examine each facial feature individually, defining the shapes and contours *within* each feature. For example, the nose is not a single shape—not merely a wedge-shaped mass —but an assemblage of upper and lower nasal masses, nostril wings, septal cartilage, and other subtle, interlocking forms. The intricate forms of the eye, ear, and mouth are analyzed in the same way.

Having visualized the head as form, we now look beneath the surface to the artistic anatomy of the head. The word *artistic* must be emphasized. This is not a medical anatomy book and the student is not expected to memorize Latin names. The

function of artistic anatomy is to provide the artist with a sound basis for creative expression. As shown in these pages, the musculature of the head reveals the blend of expressive form and anatomical function which has inspired draftsmen from the time of Leonardo.

With this structural information in mind, we can now examine the head in motion. The reader is shown how to construct a head as it rotates from front view to three-quarter view to side view; and as the head moves up and down. Finally, the reader is given a checklist of the relationships between the features; this checklist is intended to help him arrive at an accurate placement of the features as the head moves.

Wrinkle patterns are not a random phenomenon, but follow definite routes over the surface of the face. In diagrammatic drawings, the reader follows the courses of the three major wrinkle patterns; studies the types of wrinkles caused by tension, pressure, sag, and shrinkage; and watches the interaction of the wrinkle patterns.

The aging of the head is always a difficult problem for the artist. To explain the subtle changes that take place from childhood to old age, a series of drawings follow the development of a single head from birth to the age of eighty, tracing the changes in proportions and facial detail that happen gradually, year by year.

The scientific classification of head types is extremely useful to the artist. An extensive series of drawings describes the general characteristics of the three basic head types: broad-headed (brachycephalic), long-headed (dolichocephalic), and intermediate (mesocephalic). The reader notes the facial features of each head type, then sees how the various head types and their features merge in an infinite number of variations. The immense variety of human faces and features is emphasized in a gallery of drawings surveying the various head types as they appear in racial and ethnic groups around the world.

Drawing the Human Head concludes with a selection of great heads in sculpture, painting, drawing, and the graphic arts, from the time of the Greeks to the art of our own century. The purpose of this gallery is to document the principles of head construction upon which this book is based. The reader will discover a remarkable continuity from the work of anonymous Greek and Roman sculptors, through the great artists of the Renaissance and Baroque periods, down to such contemporary masters as Picasso and Rouault.

All have drawn strength and inspiration from the classical conception of the head which is summarized in these pages by a masterful draftsman and an outstanding teacher.

Donald Holden

DRAWING THE HUMAN HEAD

1.
Basic
Structures
and Forms

GREAT MASSES

The basic shape of the head consists of two major divisions. The first and greater part is the egg-shaped brain case of the skull: the *cranial mass.* The second and lesser part is the tapered half-cut cylinder of the face and lower jaw: the *facial mass.*

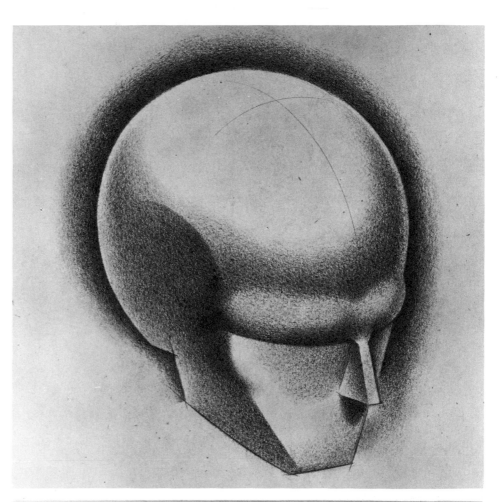

Head Form,
Three-Quarter Down View

Head Form,
Three-Quarter Up View

Cranial Mass

The cranial mass is quite even
and regular: a simple, curved
dome in general outline.

Facial Mass

The facial mass, on the other
hand, is uneven and irregular:
a somewhat hard-cornered, tri-
angular form.

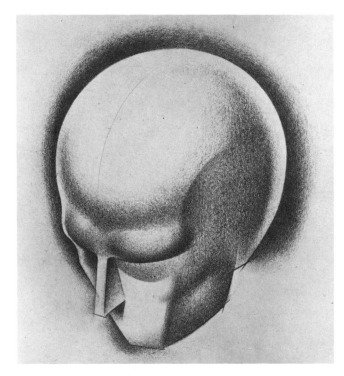

Cranial Mass,
Three-Quarter Down View

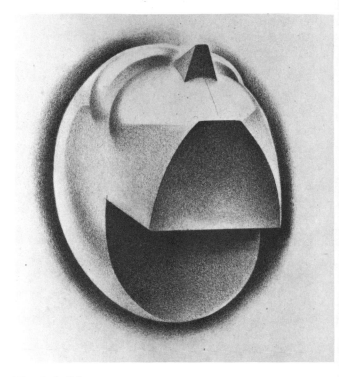

Facial Mass,
Extreme Up View

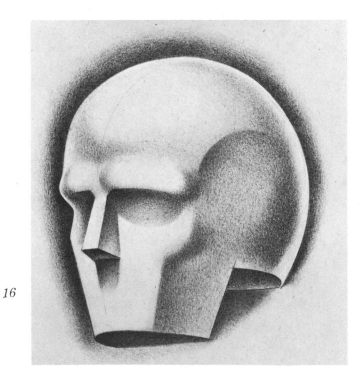

Cranial and Facial Masses,
Three-Quarter View

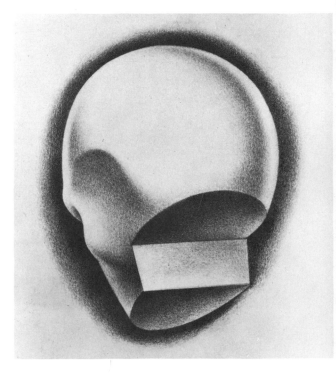

Lower Jaw Form,
Back View

16

Contour of Cranial Mass

Seen from the side, the cranial mass curves upward from the mounded ridge of bone just above the rim of the eye socket. This is the *superciliary arch* or visor of the brow. Beginning at the frontal depression in the bridge of the nose the cranium rises up the forehead to the vault of the skull and sweeps backward across the crown in a great curve toward the lower occipital bulge at the base of the head. The base line of the skull then proceeds horizontally forward to meet the hinge of the jaw. From the jaw hinge, the brain case line continues obliquely upward to the starting point at the bridge of the nose. This line forms the boundary between the two great masses of the head: the cranial mass above, and the facial mass below.

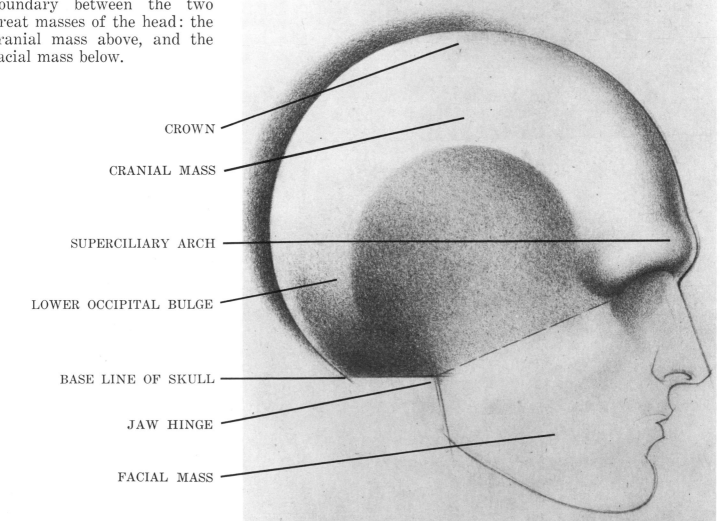

CROWN

CRANIAL MASS

SUPERCILIARY ARCH

LOWER OCCIPITAL BULGE

BASE LINE OF SKULL

JAW HINGE

FACIAL MASS

17

Contour of Facial Mass

The facial mass descends along the projecting nasal line from the bridge of the nose. At the point of the nose, the facial mass scoops sharply inward and swings over the bulge of the teeth to the protruding mound of the chin. From here, the contour moves angularly up the lower edge of the jaw line to the angle of the jaw. Here it rises steeply, almost vertically, to the jaw hinge in the base of the head. The boundary line, connecting the hinge with the nose bridge, divides the facial mass from the cranial mass.

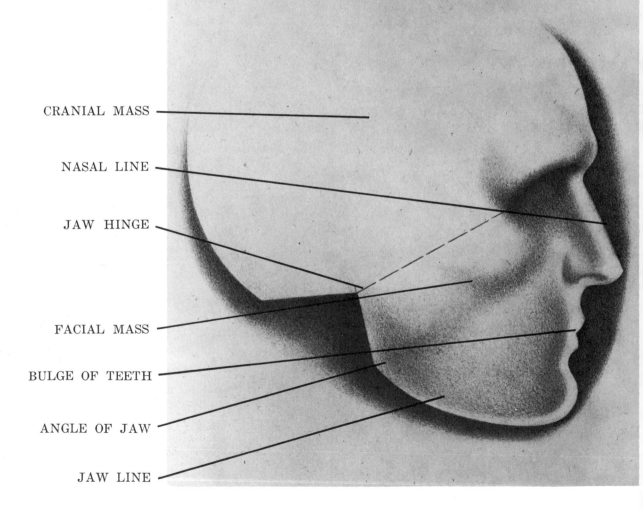

CRANIAL MASS

NASAL LINE

JAW HINGE

FACIAL MASS

BULGE OF TEETH

ANGLE OF JAW

JAW LINE

Proportions and Measurements

The size relations between the cranial mass and the facial mass reveal two different sets of proportions.

CRANIAL MASS

FACIAL MASS

FRONT VIEW

From a direct front view, the cranial mass and the facial mass tend to be *equal* in size.

SIDE VIEW

From a side view, the cranial mass is virtually *twice* as large as the facial mass.

CRANIAL MASS

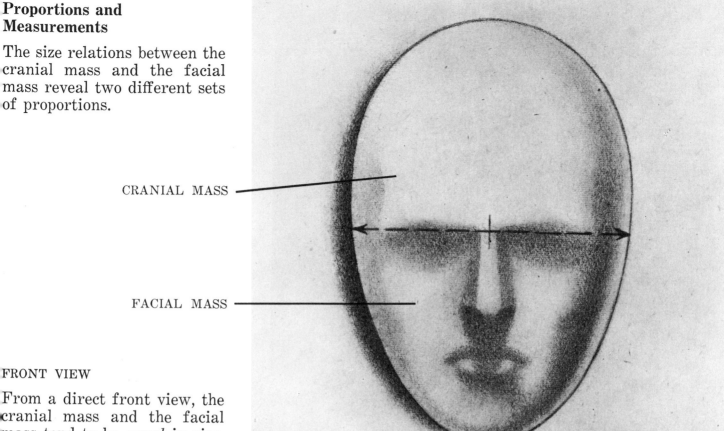

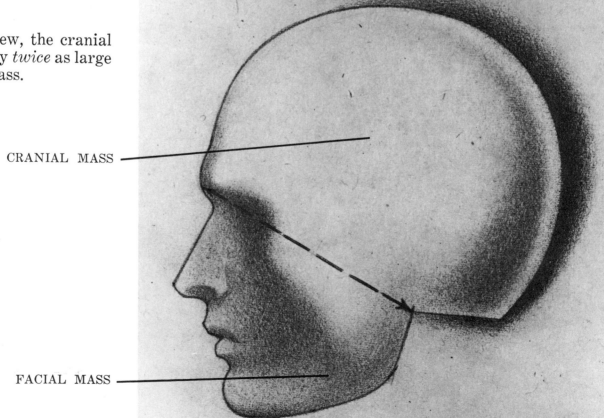

FACIAL MASS

19

DRAWING CORRECT
FRONTAL PROPORTIONS

When you draw the head, it is helpful to visualize these proportions in the following manner.

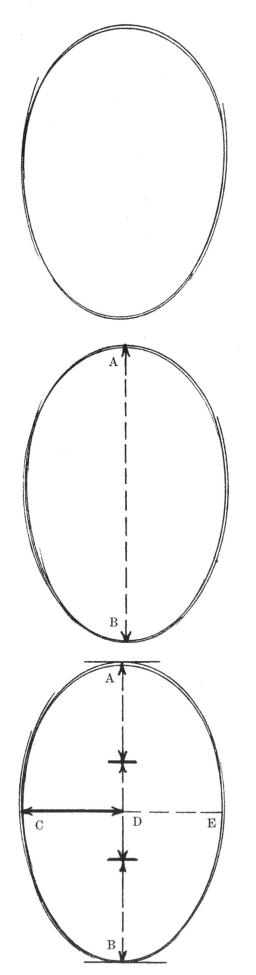

STEP 1

Frontally, the head, with its two great masses, is clearly egg-shaped. In order to establish the shape correctly, first draw the outline of this ovoid form.

STEP 2

Now divide the simple head shape lengthwise in equal halves with a center line (A-B) drawn from crown to chin.

STEP 3

Take the *width* of one of the halves of the egg (C-D) and measure this against the vertical center line (A-B). If you have drawn the egg properly, the center line (A-B) should be three times the length of the horizontal line (C-D). Thus, the *total width* of the head (C-E) is just two thirds the length. If your first drawing of the head shape is too long or too short, use these space divisions to eliminate the distortion.

DIVIDING CRANIAL
AND FACIAL MASSES

Now, using this egg shape as
your norm for the front view
head, draw it again and divide
it with a horizontal line (A-B)
midway between top and bot-
tom. This line reveals the *equal
measures* of the two major
masses: the cranial mass
above, and the facial mass be-
low. If you then divide the egg
with a vertical line (C-D), the
point where the vertical and
horizontal lines cross (E)
identifies the position of the
bridge of the nose in the mid-
region of the head.

DRAWING CORRECT
SIDE VIEW PROPORTIONS

To establish the plan of the
side view head, take two egg-
shapes of identical size and
draw them *one over the other*,
the first upright, the second
horizontal. The downward
bulge will identify the lower
jaw. The backward bulge (the
widest part of the horizontal
egg) becomes the back of the
head. Note that the height
(A-B) and width (C-D) of
the side view head are equal.
Furthermore, if you drop
another vertical line (E-F) at
the inner edge of the upright
egg, you find that the width
(C-D) divides into three equal
parts. Finally, if you visualize
the upper egg as the cranial
mass, you will see that the
cranial mass is *twice* the size
of the facial mass.

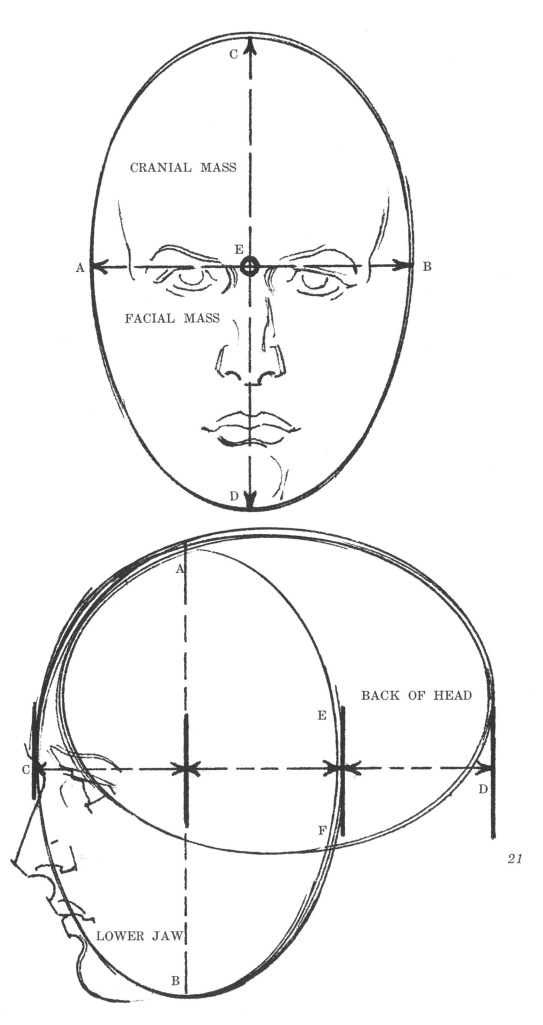

21

Drawing Cranial and Facial Masses

This series of drawings shows how to simplify the two major masses when you draw difficult views and extreme positions of the head. What is most important in this first stage is to set down a firm and correct foundation upon which to build the smaller forms. Specific details of these smaller forms are left for later refinement. See how easily a difficult view of the head may be solved by starting the drawing with the initial placement of the two great masses. Note the *flatness* of the under-jaw and skull base.

Back View

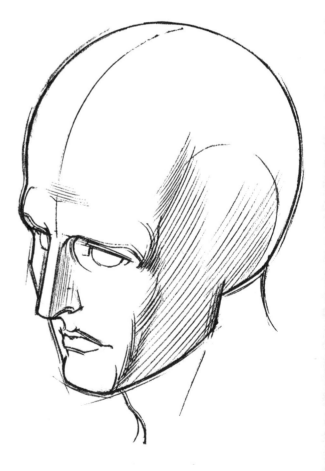

Three-Quarter Top View

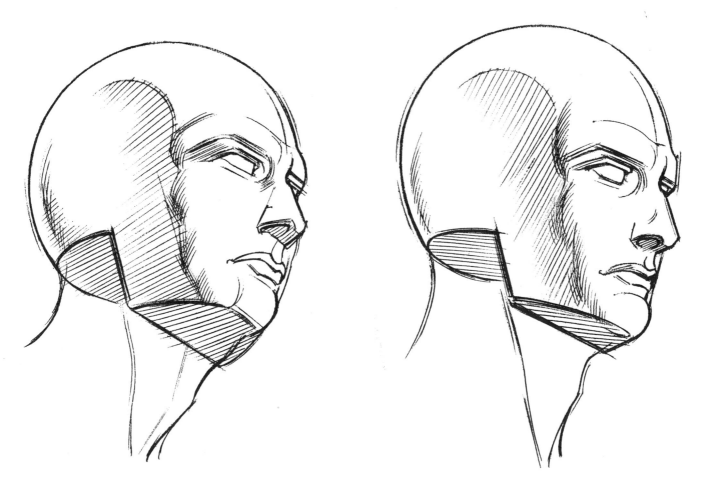

Oblique Side Up View Three-Quarter Front Up View

23

FORM STRUCTURES OF THE HEAD

The form structures are the hard, bony, skeletal parts of the head or body. Or they are the tensile, firm, cartilaginous parts. These are the rigid *framework* or *support* structures of the body, upon which all the soft, limber, or supple tissues depend. Having established the basic form of the two great masses, we will look more closely at the form structures which give the brain case and the facial region their special qualities. We shall see how the upper mass becomes a *skull* and how the lower mass becomes a *face* with features. We shall not describe these structures as mere anatomical parts, but as *forms* which are used in *drawing* the head.

Forms of Skull

Examined in detail, the cranial mass takes on the appearance of a *helmet*, flattened at the sides, with a short, thick visor projecting in front. The helmet consists of five shapes fused together.

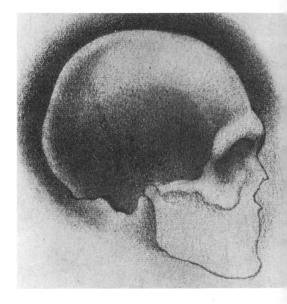

On the frontal curve of the dome, we see the shell of the forehead *(frontal bone)* which rises to the mid-region of the crown.

On top, we see the crown or vault of the dome *(parietal bone)* which partly covers the top, sides, and rear of the head.

In back, we see the rear bulge *(occipital bone)* which encases the skull base.

On the side of the skull, we see the slightly concave temple wall *(temporal bone)*.

In the lower front region we see the heavy visor of the brow *(superciliary arch)*. This prominence is actually a continuation of the forehead frontal bone, but it is useful to visualize it as a separate form.

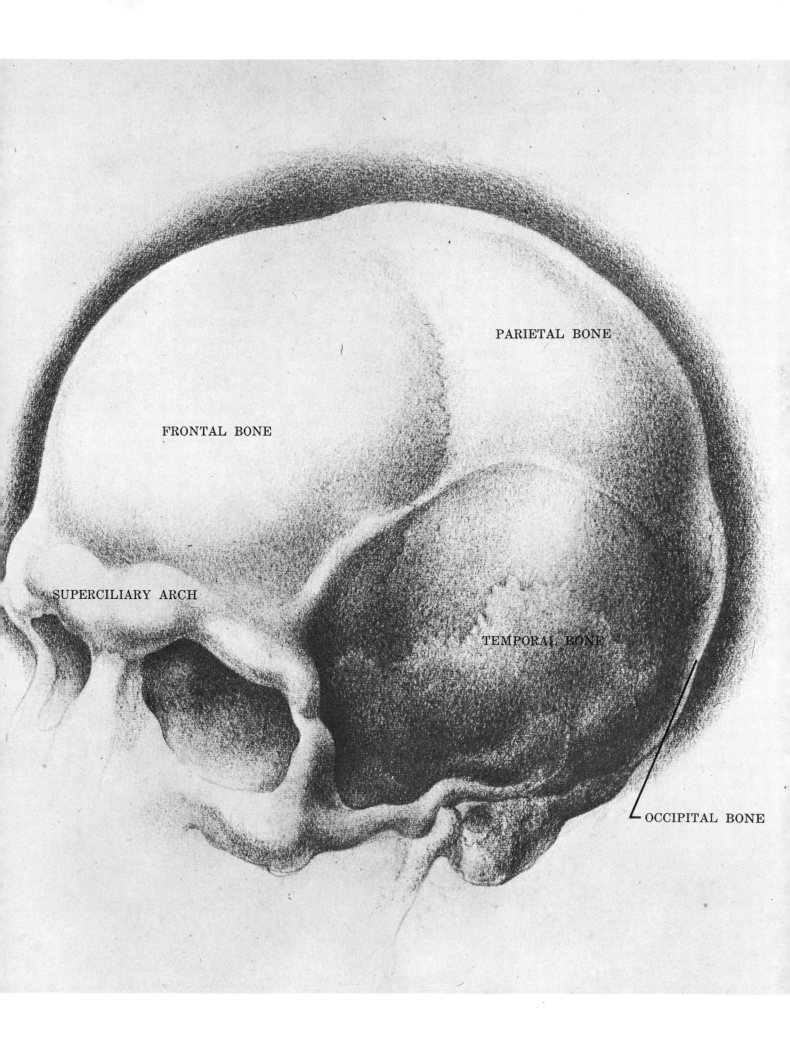

PARIETAL BONE

FRONTAL BONE

SUPERCILIARY ARCH

TEMPORAL BONE

OCCIPITAL BONE

Four Close-ups of Skull

In these close-ups, see how the five fused shapes of the skull are expressed.

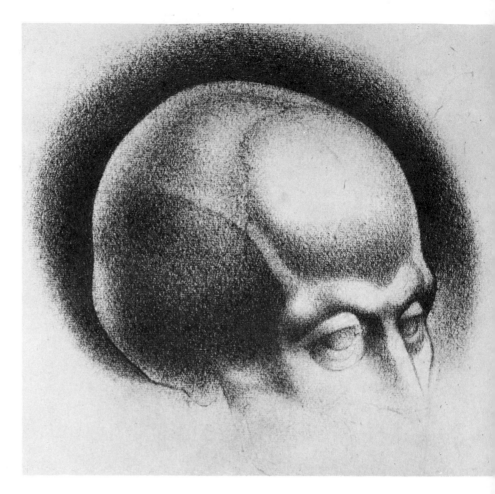

CROWN

The *crown* has its own subtle but distinct contour, with slight dips where the five shapes meet.

REAR BULGE

The *rear bulge* is a somewhat stronger shape than the crown. The top edge of this bulge aligns with the upper eyelid.

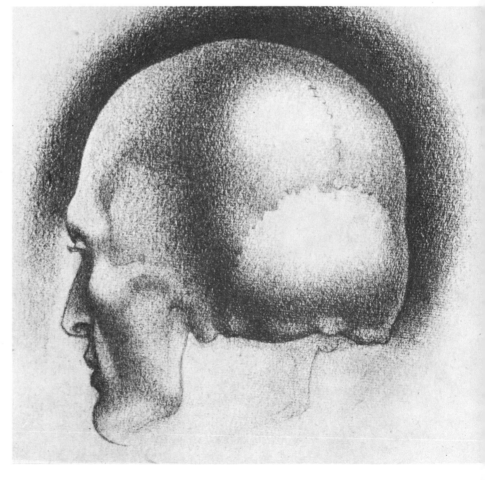

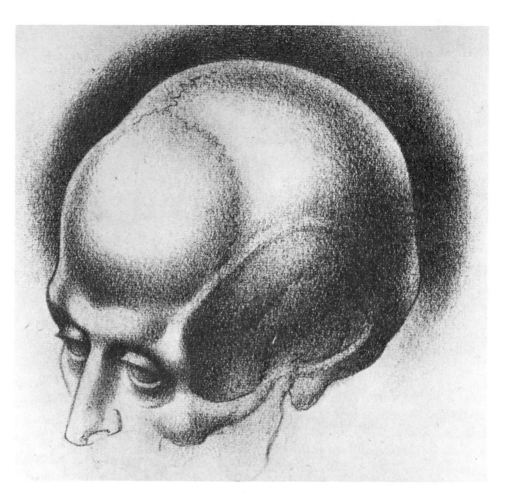

TEMPLE WALL

The *temple wall* curves inward.

BROW VISOR

The *brow visor* is a powerful, thrusting form, especially noticeable in a three-quarter front view.

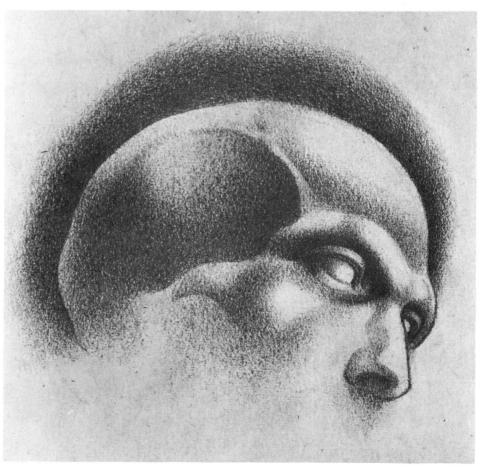

27

Forms of Facial Mass

Although the cranial mass is larger, the smaller facial mass commands more interest and attention, for it is here that the more decisive features appear. Indeed, the visual impact of the face and its features is so great that the student must force himself *never* to forget the relative proportions of the two great masses. Failure to give the cranial mass its correct size always labels a drawing as amateurish. In the facial mass there are ten visually prominent forms. One of these is primary and dominant: the lower jaw. The remaining nine are the eyes, nose, and other features.

Lower Jaw (Mandible)

The jaw is the decisive form in producing the contour of the face as a whole. It is the *largest* bone structure of the facial mass. Beyond this, it has the unique characteristic of being the only *movable* bone structure of the head. In general, the lower jaw is shaped like a horseshoe.

At its front—the central region of the chin mound (1)—the jaw is tight, constricted somewhat angular. Just above is the dental arch (2) of the lower teeth. As the arch curves back and ends, the jaw widens and develops two broad, plate-like structures (3) (the *ramus*) which rise steeply to each jaw hinge (4) alongside the ears. The jaw ends in two spur-like formations above each ramus, neither of which appears on the external aspect of the face.

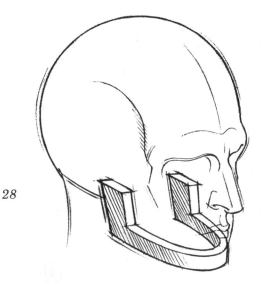

Horseshoe of Jaw:
Three-Quarter Down View

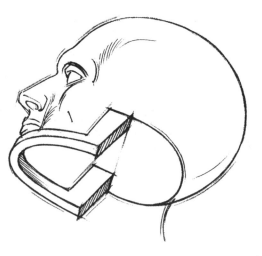

Horseshoe of Jaw:
Three-Quarter Up View

(4) JAW HINGE

(3) RAMUS

) DENTAL ARCH

(1) CHIN MOUND

PROFILE OF JAW

From a side view, the base of the jaw is not horizontal. From the chin, it gently rises 12 to 15 degrees up to the angle of the jaw. From the angle or jaw corner, the contour is a steep diagonal to the jaw hinge.

TWO CLOSE-UPS OF JAW

Observe how the horseshoe of the jaw is drawn. The *chin* is angular. The jaw corners are aligned parallel with the chin. The *ramus projections* are widespread and equal in height.

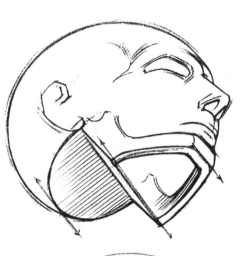

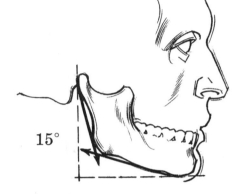

Facial Features

The nine secondary forms of the face, small as they are, have the greatest visual impact. The subtle differences in these forms are what make one face different from another. Although the visor or brow ridge is really part of the cranium, note that we also include it here as a facial feature. The nine secondary feature forms are:

Brow ridge or visor of the cranial cap, widespread and horizontally arched across the mid-facial region.

Tapered wedge of the nose, descending steeply from under the brow ridge.

Eye socket, depressed and placed against both sides of the nose, opening immediately below the arch of the brow.

Cheek bones, thickly formed, mounded along the lower outside rim of each eye socket.

Barrel of the mouth, rounded and heavy-set, protruding below the prominent overhang of the nose.

Box of the chin, below the mouth barrel and farther forward.

Angle of the lower jaw or jaw corner, forming the rear edge of the facial area.

Side arch of the cheek bone, starting from the cheek bone, swept back and arched toward the mid-ear.

Shell of the ear, beyond the upper edge of the jaw, at the side of the face.

BROW RIDGE

SIDE ARCH

CHEEK BONE

ANGLE OF JAW

MOUTH BARREL

CHIN BOX

Proportions and Measurements

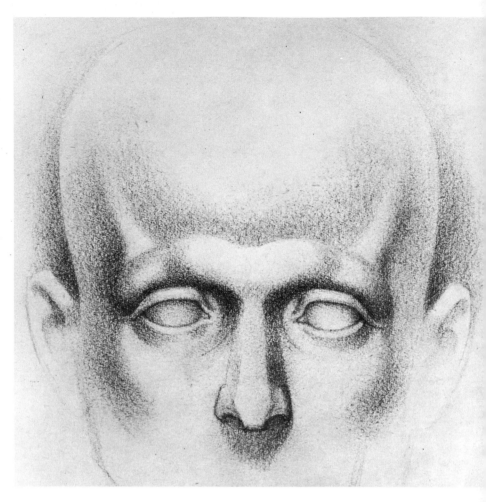

BROW RIDGE

The middle of the brow ridge, at its *base*, is the depressed bridge of the nose. This is the exact midpoint of the head. Here, at the midway line, the head is *five* eye-lengths wide. The brow ridge itself is *four* eye-lengths wide.

NOSE

Centrally located in the facial mass, the tapered wedge of the nose descends to a point midway between the bridge of the nose and the base of the chin. The width of the nose at its base is *equal* to the width of the eye.

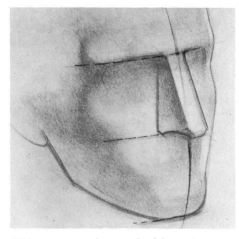

Distances from bridge to midway point to base of chin are equal.

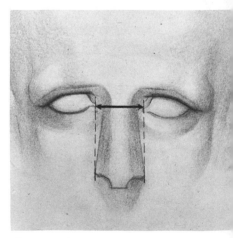

Base of nose is one eye wide

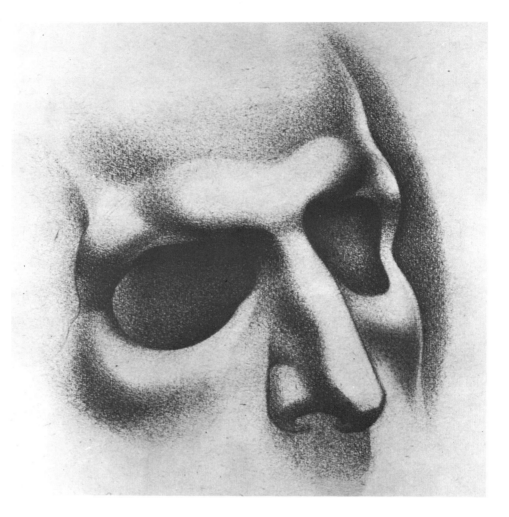

EYE SOCKET

Starting at the base of the brow bone, the socket extends *halfway* down along the length of the nose. The outer edge of the socket lies just above the projecting cheek bone.

CHEEK BONE

The base line of the cheek bone aligns with the base of the nose. In frontal views, the inner depression of the cheek bone is roughly midway along a diagonal line (30 degrees) from the eye socket to the angle of the jaw.

33

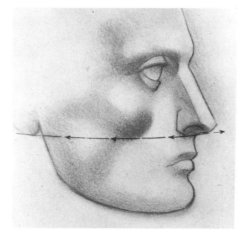

Cheek bone aligns with base of nose.

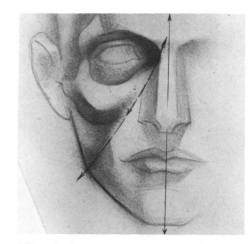

Cheek bone depression is midway on diagonal line.

MOUTH BARREL

Starting at the nose base, the mouth barrel extends *two thirds* the distance down from the nose to the chin. The sides of the barrel align with the *centers* of the eye sockets.

CHIN BOX

Projecting from under the mouth barrel, the chin extends one third the distance upward to the nose. At its widest point, the chin box is *equal* to the width of the mouth barrel.

JAW CORNER

The angle of the lower jaw aligns with the lower lip of the mouth barrel.

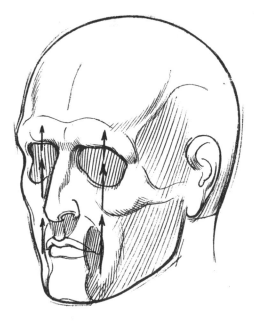

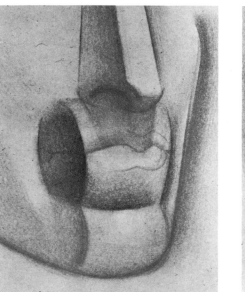

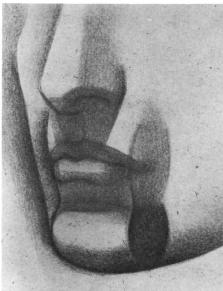

Mouth barrel aligns with centers of sockets and widest points of chin.

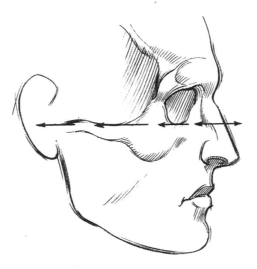

CHEEK BONE ARCH

The side arch of the cheek bone starts at the *lower rim* of the eye socket, and aligns with the midpoint of the nose. The arch ends just below the *middle* of the ear, in line with the back edge of the jaw.

EAR

The ear begins at a line drawn up from the rear edge of the jaw. The ear base aligns with the *base* of the skull, the base of the cheek bone, and the base of the nose. The top of the ear aligns with the protruding brow ridge. The peak of the eyebrow hair will identify the height of the ear, in relation to the brow.

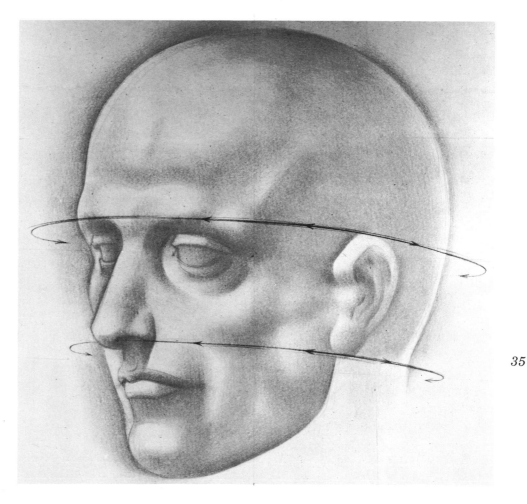

SUPERCILIARY ARCH

ZYGOMATIC BONE

REFINEMENT OF FEATURES

Among the nine feature forms, four have a more complex and involved quality: the eye, nose, mouth, and ear. Two of these are carried to a new phase of form development. Examining the mouth bulge, we shall observe the special quality of the fleshy cover, the *lips*. Drawing the eye socket, we must consider the *eyeball* and the *eyelids*.

Eye

Almost spherical and about one inch in diameter, the eyeball lies within the deep cavity (the orbit) of the eye, cushioned in fatty tissue and situated partly to the front of the socket opening. On all sides of the socket rim, the eye is protected by great projecting structures of bone: the high *nasal bone* to the inside; the overhanging brow ridge (the *superciliary arch*) above and to the outside; the protruding cheek mound (the *zygomatic bone*) below.

The eye may be conceived as a partially exposed internal organ of the body. Covering the exposed bulge of the eyeball are the upper and lower eyelids. The upper lid is more active and moveable than the lower. It is also the larger of the two lids and more fully curved. The wider arc of the upper lid swings around the eyeball at its equatorial middle. The lower lid curves around a small arc at the base of the eyeball.

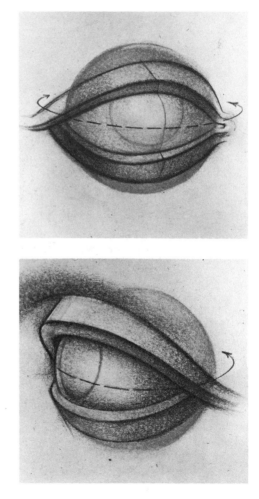

SIDE VIEW OF EYELIDS

The greater curve of the upper lid and smaller curve of the lower lid are more clearly seen from a three-quarter or side view of the eye. Note that the lower lid lies on a backward slope of *45 degrees* from the outthrust upper lid.

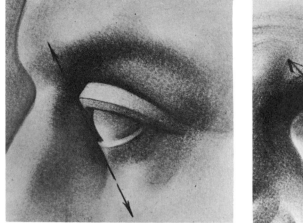
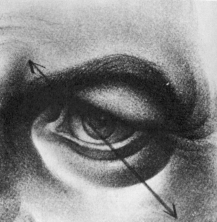

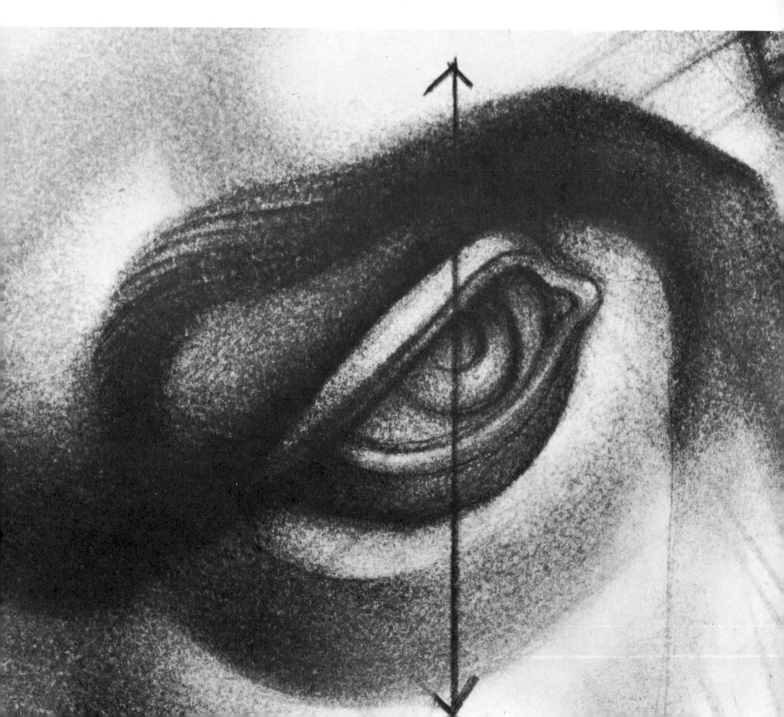

SHAPE OF EYE

The highest point of the curve of the upper lid is close to the *inside* corner of the eye, approximately one third of an eye-width away. The low point of the lower lid is one third of an eye-width from the *outside* corner.

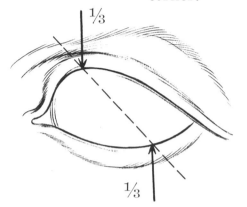

High and Low Points of Eye

AXIS OF EYE

These points, joined with a line, show the oblique *axis* of the eye. The eye opening is *not* a symmetrical almond shape.

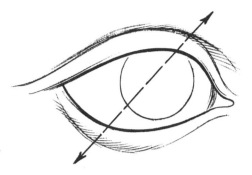

Axis of Eye

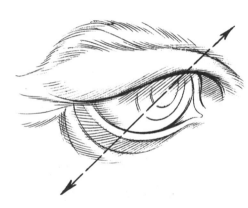

Axis of Eye:
Three-Quarter Down View

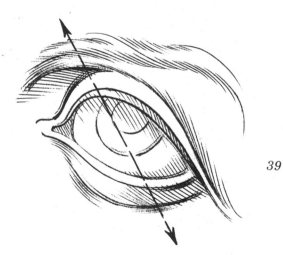

Axis of Eye:
Three-Quarter Up View

39

PLACEMENT OF PUPIL

With these curves in place, the *pupil* of the eye appears suspended from under the upper lid, and slightly above the rim of the lower lid.

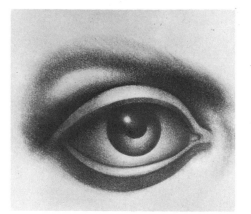

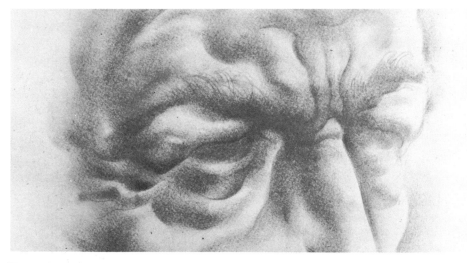

Eye Muscles,
Greatly Compressed

EYE MUSCLE FORMATION ▶

Surrounding the entire eye is a large, widespread, oval muscle: the *orbicularis oculi*. It consists of two parts: the *orbital* part, which encircles the entire eye socket from the brow ridge down to the middle cheek bone; and the *palpebral* part, the eyelids, which encase the eye itself. Both parts of the orbicularis muscle close the eye by compression. The greater orbital part vigorously contracts the region around the socket, while the eyelids curtain the eye briskly but gently.

Eye Muscles,
Partially Compressed

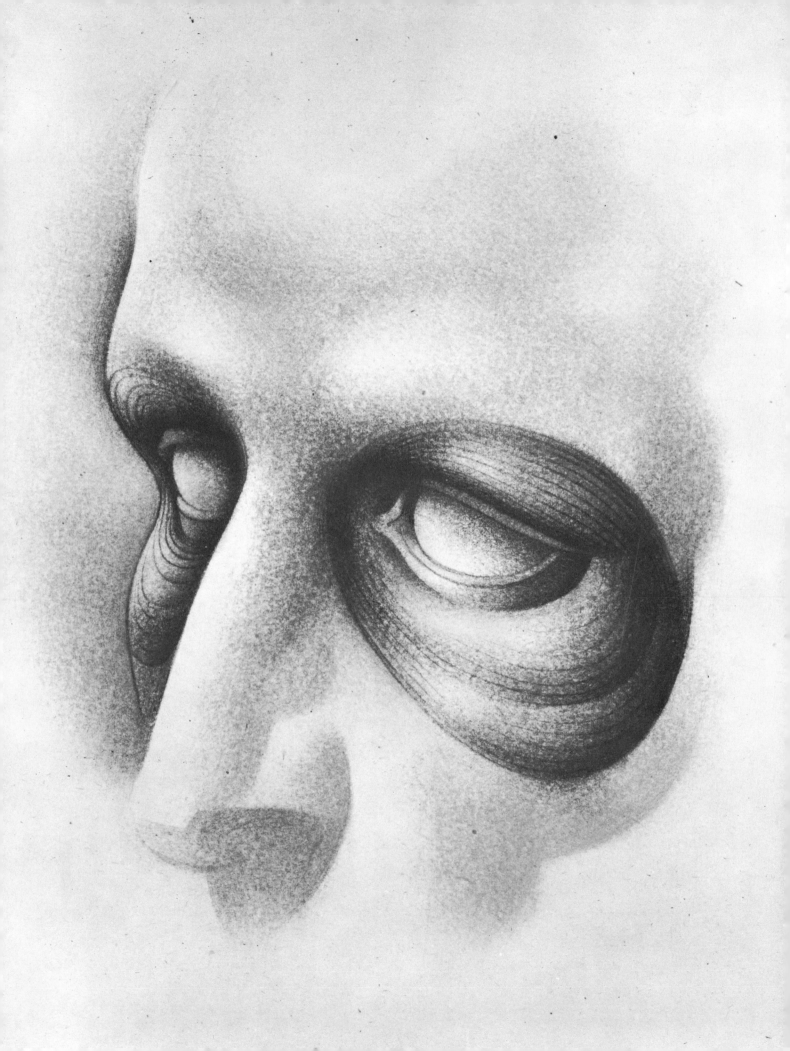

Nose

In general form, the nose is a triangular, wedge-shaped block, narrow and depressed at its root under the brow ridge, broad and prominent at its base in the mid-region of the face.

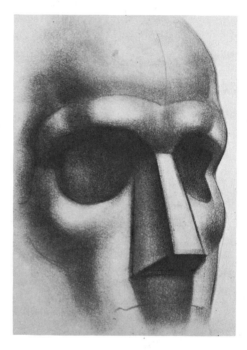

Three-Quarter Up View

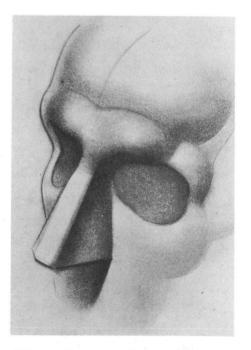

Three-Quarter Down View

FORMS OF NOSE

The nose consists of four important forms: the upper nasal mass, with its supporting nasal bone and upper cartilage; the lower elliptical ball of the nose, the *alar* cartilage with its curved hook (the *septum*); the two sidewise, expanding nostril wings, the *ala* cartilages, triangular in shape and joining the projecting ball to form the nostril cavities in the base of the nose.

UPPER NASAL MASS

BALL OF NOSE

NOSTRIL WINGS

PROPORTIONS OF NOSE FORMS

The length of the nose is half the length of the facial mass (from the nose bridge to the base of the chin). The hook of the nose attaches to the pillars of the upper lip.

UPPER NASAL MASS

The upper nasal mass generally divides the nose length at the halfway mark. Somewhat below this point, the nostril wings reach their high point.

NOSE BASE

Across the width of the nostril wings, the base of the nose measures one eye-width.

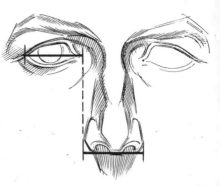

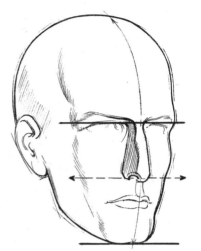

Three-Quarter View

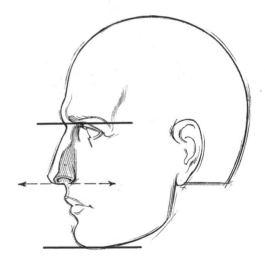

Side View

SHAPE OF UNDER PLANE

The under plane of the nose is decisively triangular, its broad base gently curved on the upper region of the mouth barrel (the *maxilla*).

SEPTAL CARTILAGE

The septal cartilage (the hook of the nose), divides the under plane from the nose tip to the base, forming the steep-sided, triangular nostril cavities.

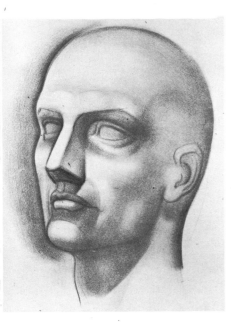

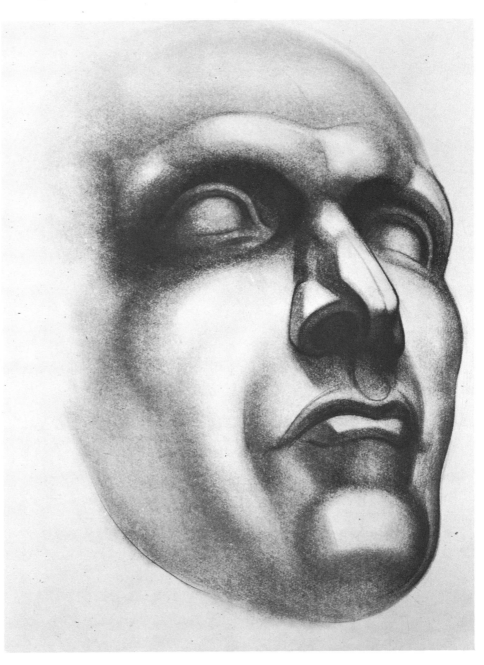

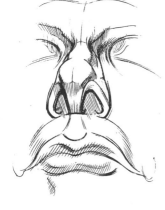

Septal Cartilage

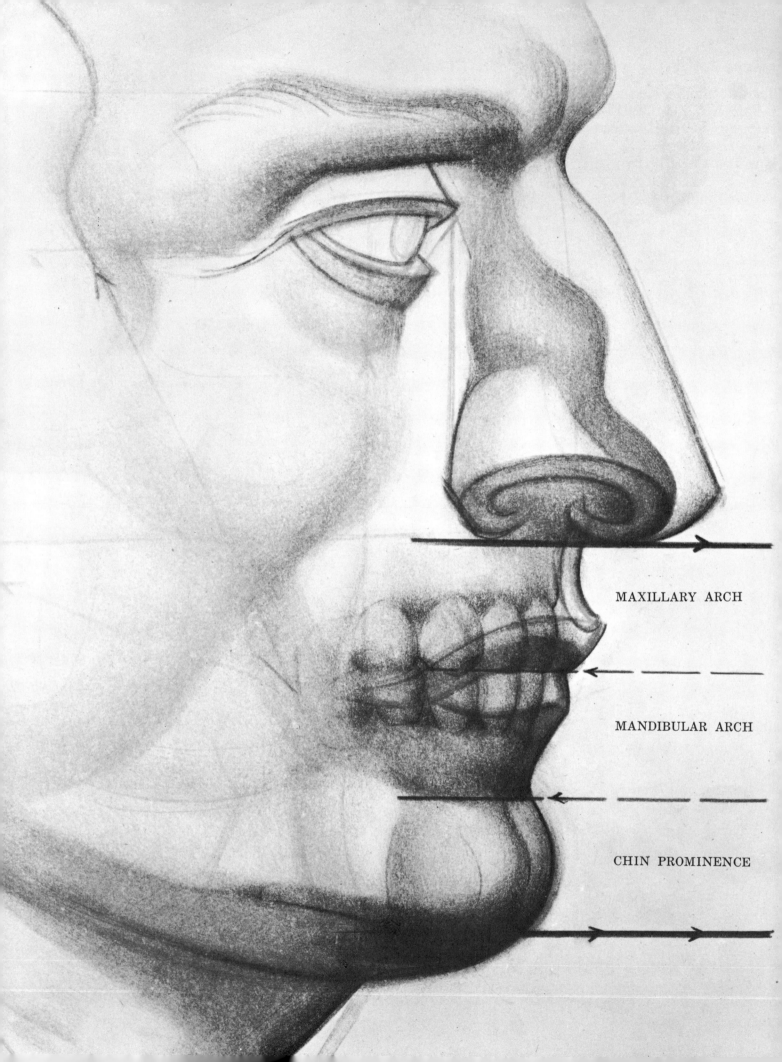

MAXILLARY ARCH

MANDIBULAR ARCH

CHIN PROMINENCE

Mouth

The substructure of the mouth is formed by the two great dental arches of the teeth: the upper *(maxillary)* arch and the lower *(mandibular)* arch. Set together, both arches support the curving mouth barrel.

◄

SIDE VIEW PROPORTIONS
OF MOUTH

From the base of the nose, the mouth bulge drops two thirds the distance from nose to chin.

FRONT VIEW PROPORTIONS
OF MOUTH

The outermost points of the dental curve align with the centers of the eye sockets.

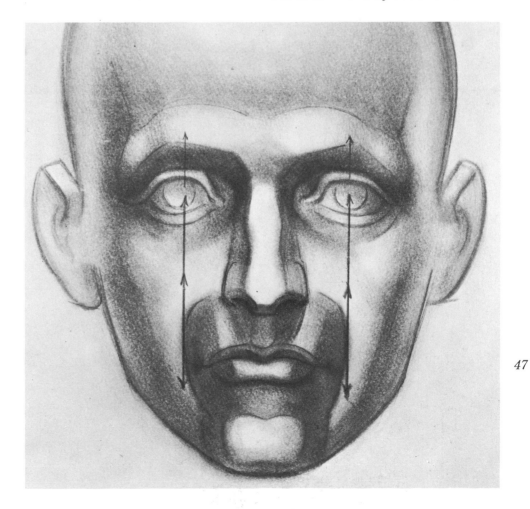

47

LIPS

Overlying the arches of the upper and lower jaws is the broad, circular mouth muscle (*orbicularis oris*), with its prominently developed lip formations.

UPPER LIP

The upper lip is a widespread, gently curving arch, grooved in the center with a shallow depression. It is shaped like a flattened, extended M.

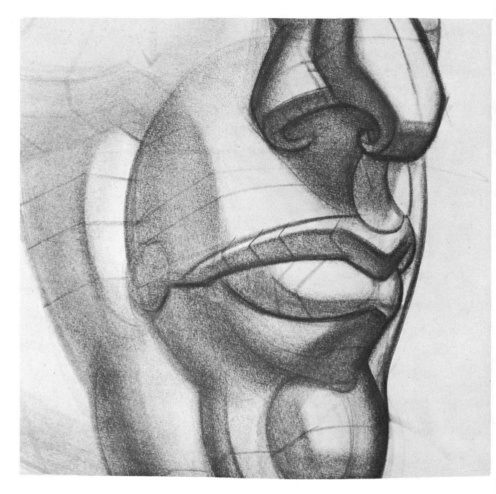

Front View, Three-Quarter

Three-Quarter Up View

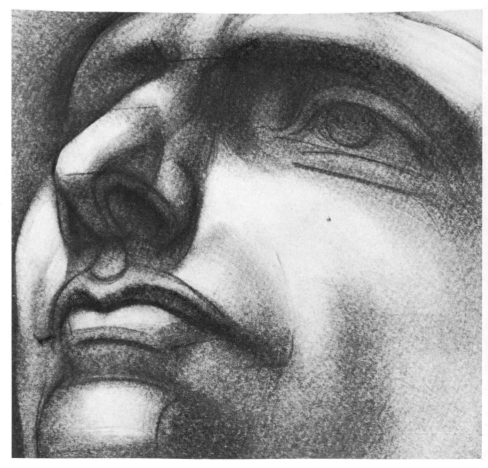

48

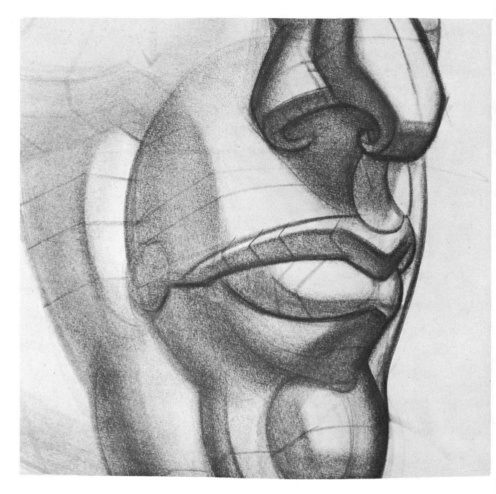

M Formation

TUBERCLE

The center of the groove *(tubercle)* on the lip thrusts slightly forward like the prow of a ship.

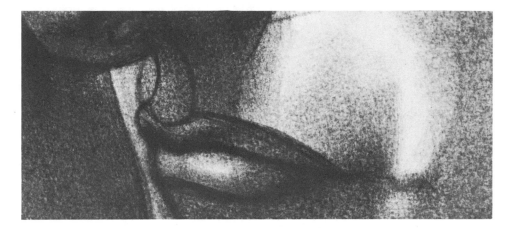

PHILTRUM

The central depression of the upper lip *(philtrum)* mounts and narrows at the septal cartilage in the base of the nose. The two edges of the philtrum are the *pillars* of the lip.

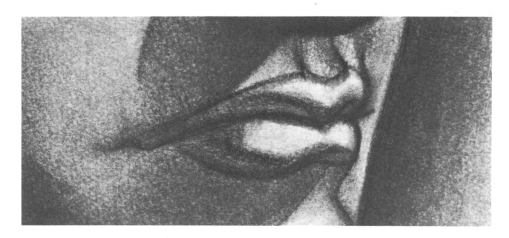

LOWER LIP

The lower lip contour is like an extended W. Two elliptical lobes develop outward from the center to form the arms of the W, while the middle of the lip dips to receive the tubercle from above. Both lips have thin marginal rims.

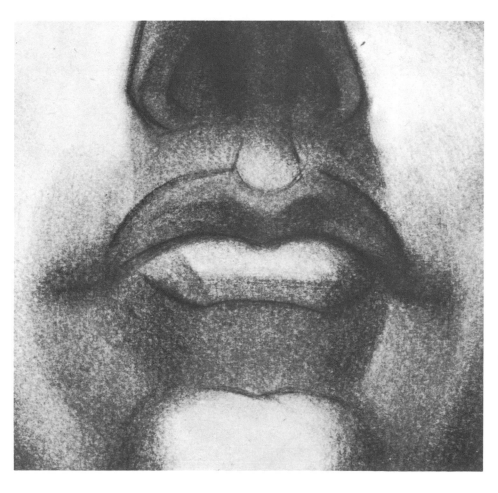

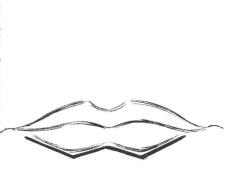

W Formation

COMPARISON OF UPPER AND LOWER LIPS

The upper lip is somewhat more arched and wider than the lower. Because it covers the greater dental arch of the upper teeth, the upper lip is the longer of the two. The lower lip is therefore recessed on the arch of the lower row of teeth. It is recessed 30 degrees in relation to the upper lip.

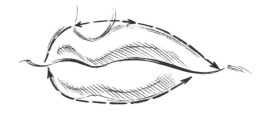

Upper lip is wider, more arched.

Side view shows recessed lower lip.

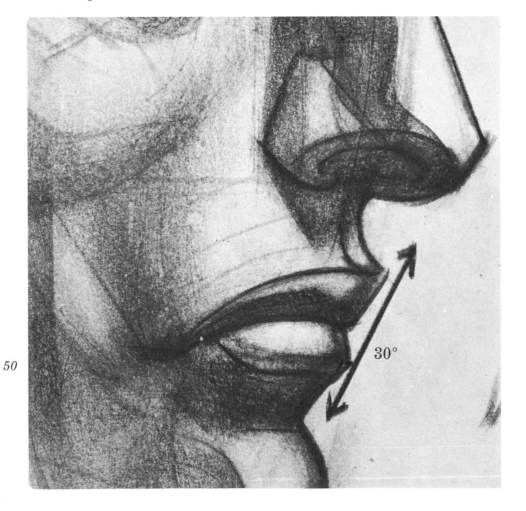

30°

INDIVIDUAL VARIATIONS

This generalization obviously does not apply to individuals with an outthrust lower jaw. In such cases, the lower lip protrudes and the upper lip recedes.

LIP MOVEMENTS

The lower lip is more active and mobile than the upper. Its placement on the free-moving lower jaw guarantees greater activity. The lower lip is also moved by an ample set of lower mouth, chin, and jaw muscles.

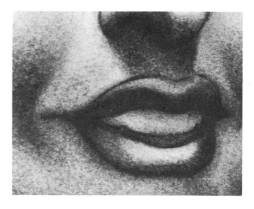

Lips Retracted and Open

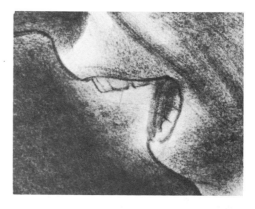

*Lips Drawn Down,
with Jaw Dropped*

Lips Compressed

51

Ear

The ear is *shell-shaped* in form and general structure. Its outer contour is formed like a C, wider at the top and narrower at the base. In the center, it has a bowl-like depression, the *concha*, large enough to admit the curve of the thumb. ▶

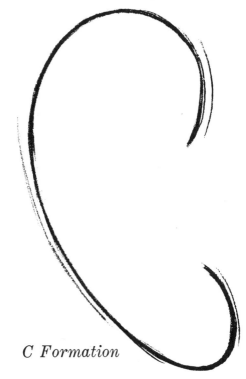

C Formation

The ear has four major forms: the wide, outer encircling rim *(helix)*; the smaller inside rim *(antihelix)*, which encloses the depressed bowl; the lower fleshy base *(lobule)*; the firm projection *(tragus)* which overhangs the opening to the ear canal. The inner rim (antihelix), divides at the top into two arms, forming a bent Y shape. Below the tragus is a small notch, just under and outside the ear canal opening. The tubercle, a small knot on the upper outside curve of the helix, is sometimes called Darwin's point. The curve of the helix turns into the bowl of the ear and implants itself in the central wall. ▼

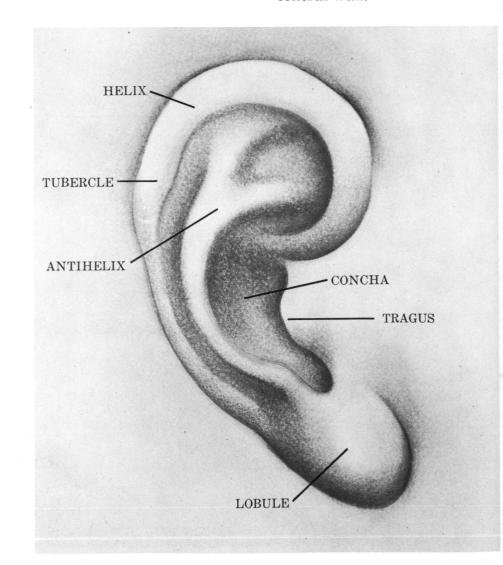

52

PROPORTIONS OF EAR

The entire ear lies within two lines drawn from the top of the eyebrow and the base of the nose. The ear divides vertically into *three* generally equal parts.

First part: from the top of the ear to the point where the helix attaches to the side of the head.

Second part: the mid-region of the ear is occupied entirely by the bowl (concha). The tragus is at the exact midpoint of the ear.

Third part: the lobe of the ear. The bottom of the lobe aligns with the base of the nose.

WIDTH COMPARED TO LENGTH

The width of the ear is *half* the length. This measure occurs *only* at the highest part of the ear, the helix or outer rim.

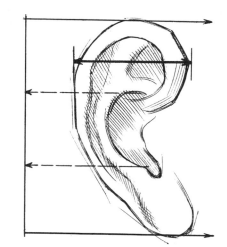

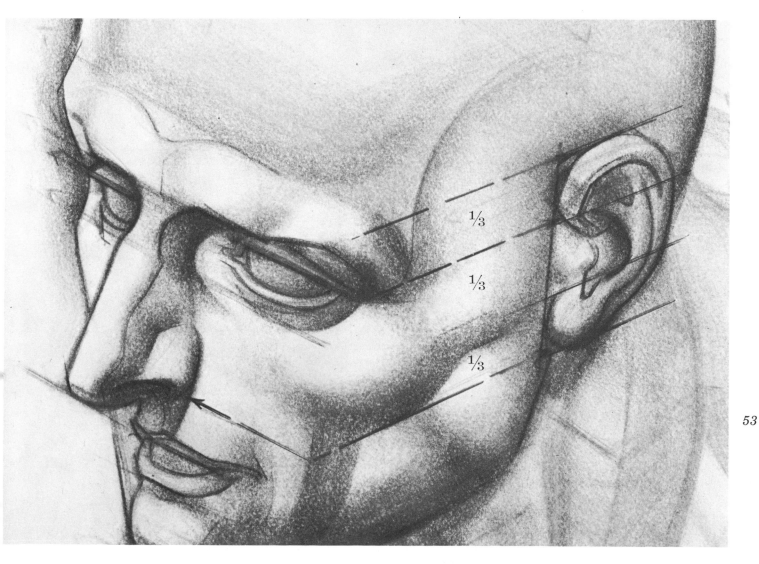

⅓

⅓

⅓

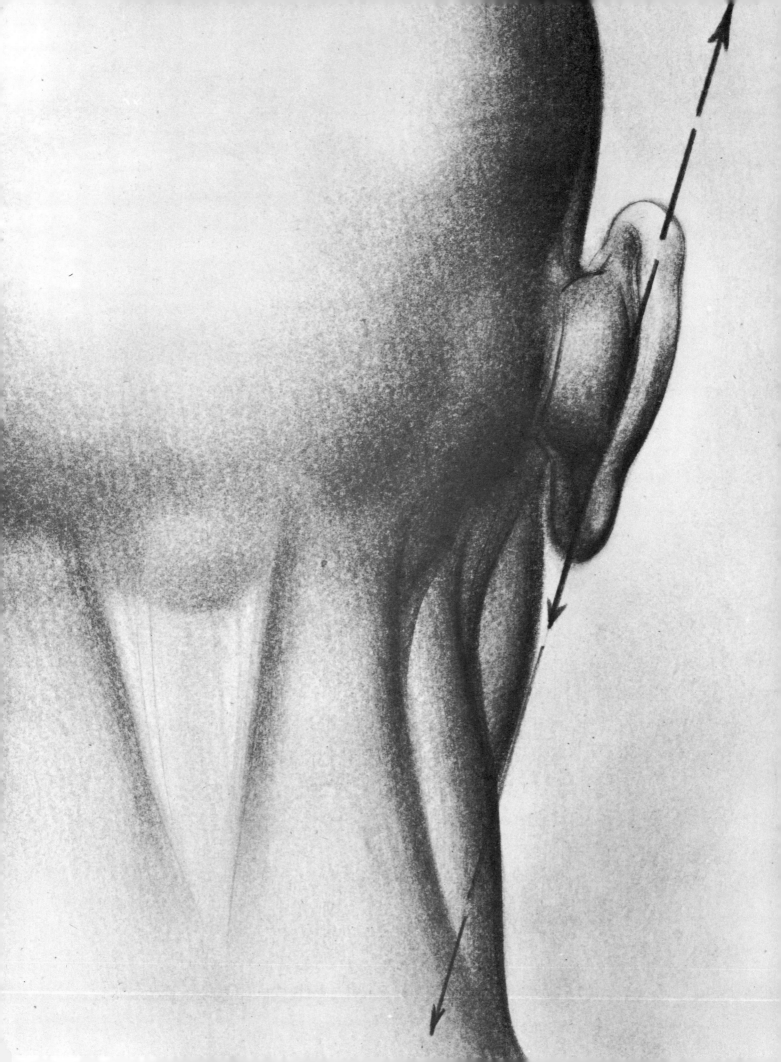

On the side plane of the head, the ear tips slightly backward at an angle of 15 degrees. Seen from the back, the outer rim of the ear stands away from the head at an angle of almost 20 degrees. This view clearly reveals the rounded back wall of the central bowl.

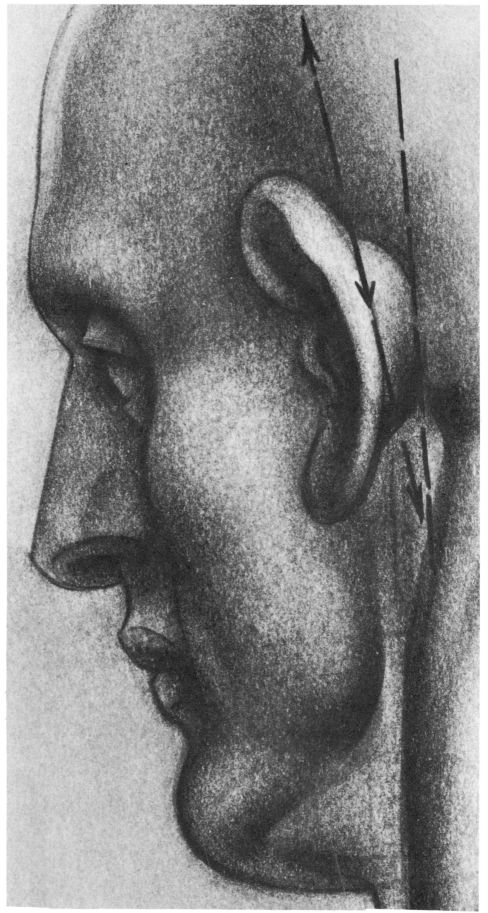

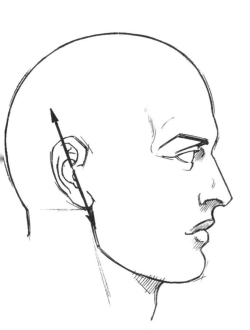

Ear tips backward 15°.

ANATOMY: MAJOR MUSCLE MASSES

The muscles of the head and face divide into four general groups: the muscles of the mouth; the muscles of the eye and eye socket; the muscles of the jaw; the superficial muscles of the scalp and face. The most important muscles are those which produce the larger surface forms, the visually prominent masses. Primarily, these are the muscles of the mouth and jaw. The eye and socket muscles are secondary. The others are minor, since they are barely seen.

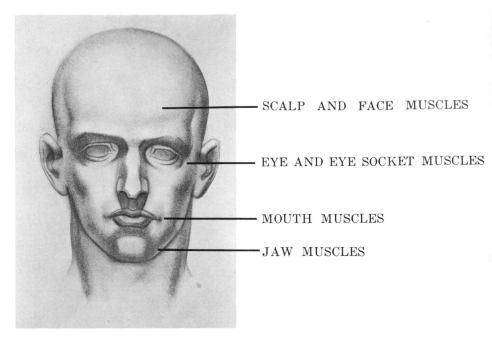

SCALP AND FACE MUSCLES

EYE AND EYE SOCKET MUSCLES

MOUTH MUSCLES

JAW MUSCLES

Jaw Muscles

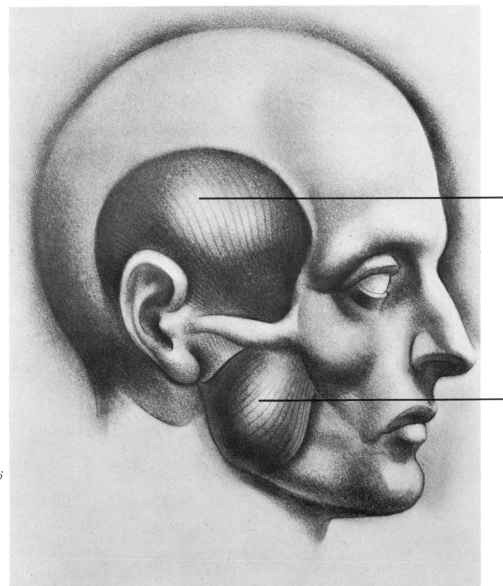

TEMPORALIS: PASSING UNDER ZYGOMATIC ARCH TO TEMPORAL BONE, ASSISTS MASSETER IN RAISING JAW AND CLENCHING TEETH.

MASSETER: RAISES JAW AND CLENCHES TEETH.

56

Mouth Muscles

LEVATOR LABII SUPERIORIS ALAEQUE NASI: RAISES HIGH INSIDE UPPER LIP, INCLUDING NOSTRIL WING.

LEVATOR LABII SUPERIORIS: RAISES UPPER LIP NEAR NOSTRIL WINGS.

CANINUS (LEVATOR ANGULI ORIS): WITH ZYGOMATICUS, RAISES CORNER OF MOUTH.

ZYGOMATICUS (MAJOR AND MINOR): RAISES MOUTH UPWARD AND OUTWARD.

ORBICULARIS ORIS: CIRCLES MOUTH, COMPRESSES AND PURSES LIPS.

BUCCINATOR: DRAWS CORNER OF MOUTH BACKWARD, FLATTENS AND TIGHTENS LIPS.

RISORIUS: PULLS CORNER OF MOUTH SIDEWARD AND OUTWARD.

TRIANGULARIS (DEPRESSOR ANGULI ORIS): PULLS CORNER OF MOUTH DOWNWARD.

QUADRATUS (DEPRESSOR LABII INFERIORIS): PULLS LOWER LIP DOWNWARD AND OUTWARD.

MENTALIS: RAISES AND TIGHTENS CHIN, THRUSTS LOWER LIP UP AND OUTWARD.

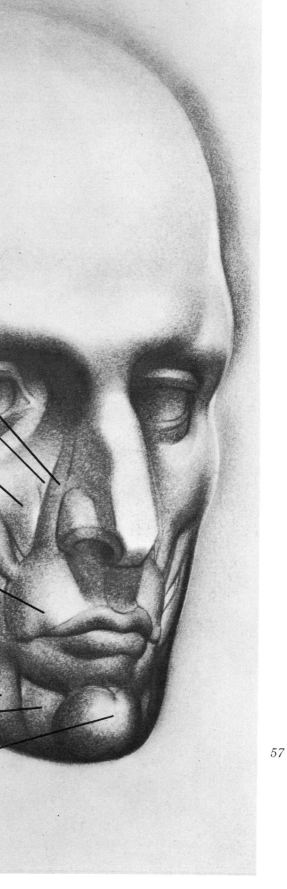

CORRUGATOR: ASSISTS ORBICULARIS IN COMPRESSING SKIN BETWEEN EYEBROWS.

ORBICULARIS OCULI: CLOSES EYELIDS AND COMPRESSES EYE OPENING FROM ABOVE AND BELOW.

PROCERUS: ASSISTS ORBICULARIS TO TIGHTEN INNER EYE SLIT BY WRINKLING SKIN IN ROOT OF NOSE.

EPICRANIUS, FRONTAL PART:
DRAWS SCALP TO FRONT,
WRINKLES FOREHEAD SKIN
AND PULLS EYEBROWS
UPWARD.

EPICRANIUS, OCCIPITAL PART:
DRAWS SCALP BACKWARD
AND DOWNWARD.

PLATYSMA: LYING CHIEFLY
ON NECK, DRAWS LOWER LIP
DOWNWARD AND OUTWARD.

Function of Anatomy

The purpose of *artistic anatomy* is not to dissect and expose muscles, but to analyze and evaluate *forms*. The student must observe which forms are major, minor, or superficial; which ones have significant visual impact; and which ones are scarcely visible. Furthermore, he must evaluate head forms in general, studying the relations between bony skeletal forms, rigid cartilaginous forms, and flexible muscular forms. The artist studies anatomy not as an end in itself, but as a groundwork for the expressive interpretation of visual form.

59

Eye and Socket Muscles

2.
Head
Movement

To draw the *movement* of the head means to record the changing aspects and relations of head forms when the head changes position. How do we draw the varied views of the head? How are the major masses related when the head changes direction? How are the features expressed when seen from above and below? How are the significant planes and structures positioned when the head turns? When the head moves, a new set of *form relations* appears. The student must strive to observe these changes and draw them without distortion.

HEAD ROTATION

To draw the head in a full front view or a direct side view is elementary. The simple relations of the cranial and facial masses, front and side, have been explained in Chapter 1. The difficulty occurs when the head rotates from a front view to a three-quarter view. A question arises about the *back* of the head. How much of the cranial bulge will be shown at the rear in relation to a given amount of turn? Here is a simple solution.

Constructing a Rotating Head

Step 1: Draw a full front view head shape in correct proportion.

Step 2: Now draw horizontal (A-B) and vertical (C-D) lines which divide the ovoid shape at the midpoint in both directions. These are the *axis lines:* the horizontal axis (A-B) identifies the brow line; the vertical axis (C-D) defines the bilateral symmetry of the face and features.

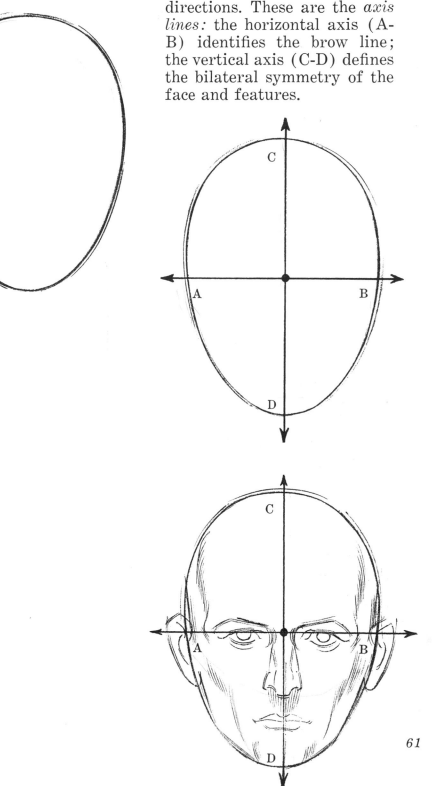

61

Step 3: Our chief interest is in the *vertical* axis, the center line which records every sidewise movement of the face and features. To make the head turn from a front view to a new position, draw a new vertical center line (C-E-D) from crown to chin. This line *curves* to show the characteristic bulge of the ovoid mass. The midpoint (E) of the curve is at the horizontal brow line. Keep brow line level and unchanged.

Step 4: On this curved line (C-E-D), the new center of the face, sketch the wedge of the nose in three-quarter view. Then lightly draw the lips and a new outline on the right side of the face. This new outline must be held generally within the original ovoid shape.

Step 5: Now, how much of the cranium will appear at the rear? The answer is clear. The amount of turn the head makes in *front* will produce a *similar amount* of turn in *back*. Measure the distance between the midpoint of *old* center line (F) and the midpoint of the *new* center line (E). Add this measure to the head at the rear (A-G). This gives you the correct amount of cranial bulge in back, corresponding to the amount of turn in front. Measurement A-G equals E-F.

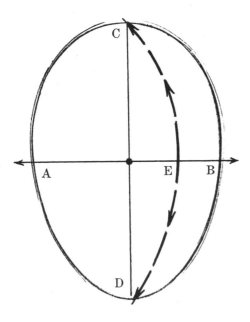

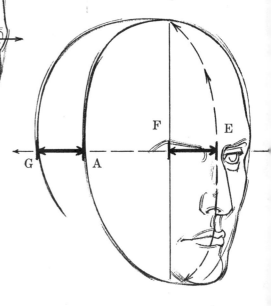

Drawing a Three-Quarter View

With these measurement lines in place, complete the shape of the skull and draw in the features. This is a good time to review the details of the secondary forms we studied in the preceding chapter. Check the horizontal line-up of the nose base, cheek bone, ear, and skull base. The edge of the mouth and chin should align with the center of the eye. The ear should attach on a horizontal line drawn from the outside corner of the eye.

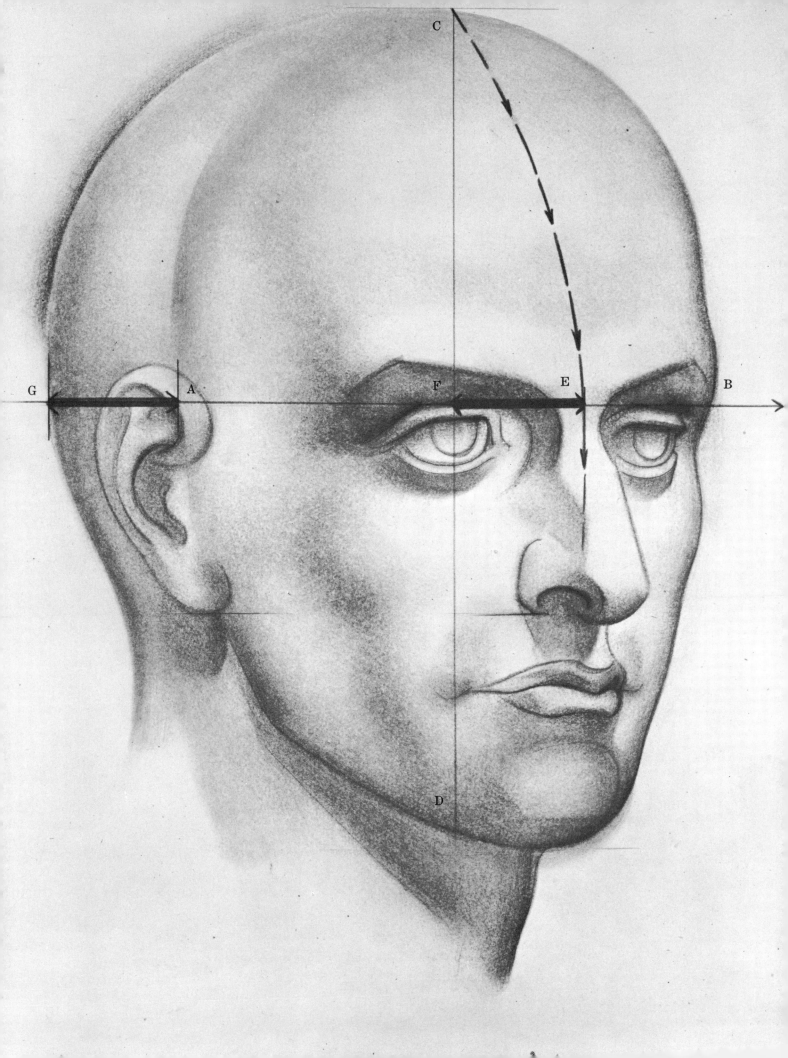

Four Views of Head in Rotation

When you have mastered the procedure, try it on a series of heads showing various turns to left and right. In all views, note how each measure A-B equals measure C-D.

Proof of Method

Let us, for the sake of argument, raise an important question: Is the foregoing method reliable for *any stage* in the rotation of the head? It is. Here is the proof. Suppose that we wish to give the head its greatest possible rotation from a front view to a full side view. First, we draw the front ovoid shape and divide it, as before, in halves. We then take the measure A-B (half the width of the front view head) and transpose it to C-D, which completes the cranial mass. Finally, we sketch in the full profile. Our method gives us a good side view head. *But is it proportionally correct?* Recall Chapter 1, in which we demonstrated that the side view head divides vertically into three equal parts. Measure the above head: A-B, B-C, and C-D are exactly equal.

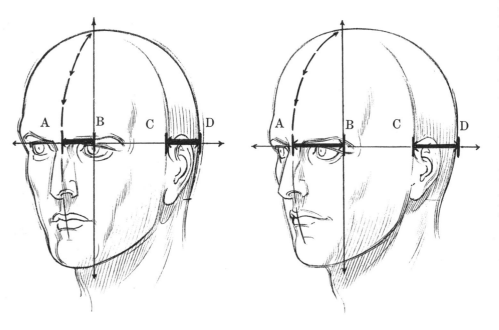

Slight Turn to Left *Greater Turn to Left*

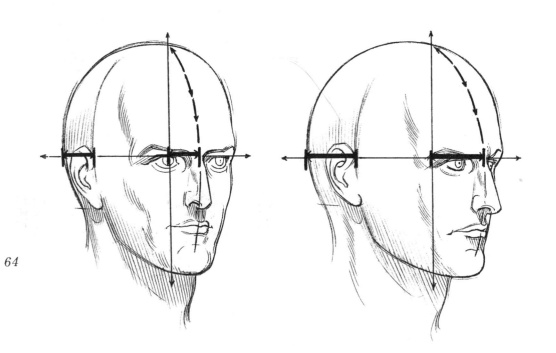

Slight Turn to Right *Very Great Turn to Right*

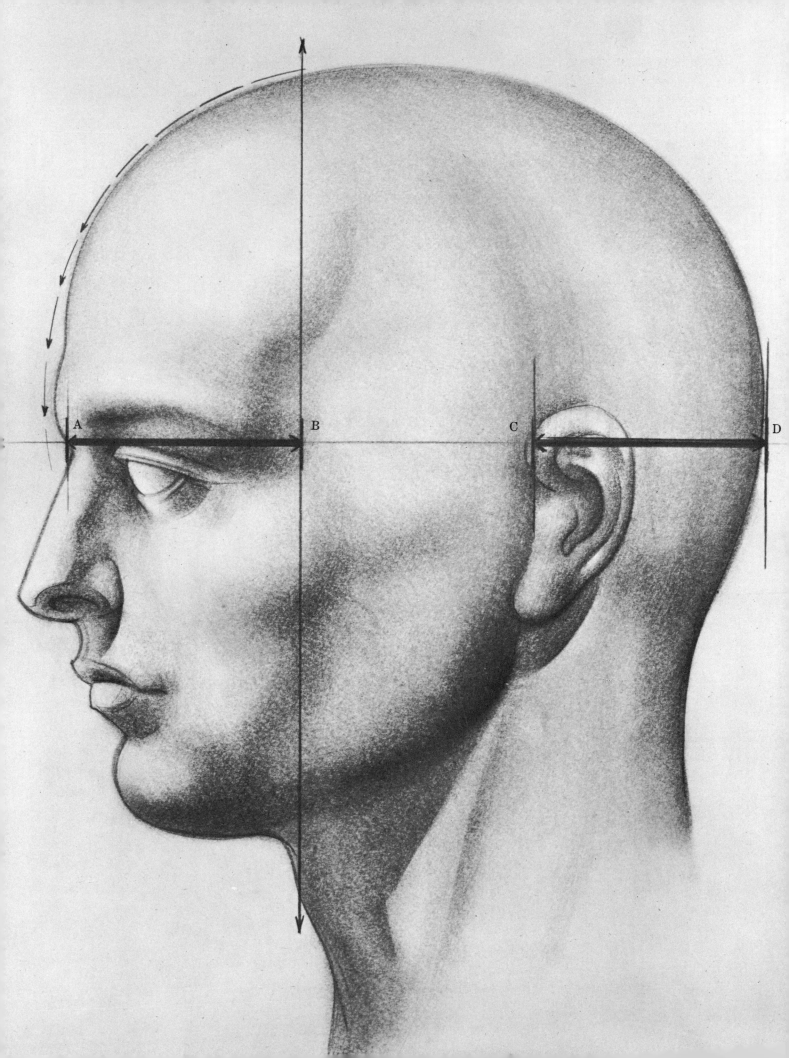

A　　　　　　　　B　　　　　　　　C　　　　　　D

POSITIONING SIDE PLANE AND JAW LINE

In drawing the many possible views of the rotating head, two problems impede our attempts to achieve sound proportions. These are the placement of the *side plane* (A-B) and jaw line (C-D). The side plane, which begins at the corner of the brow, changes with every turn of the head. But the jaw line tends to remain *unchanged* regardless of the rotation!

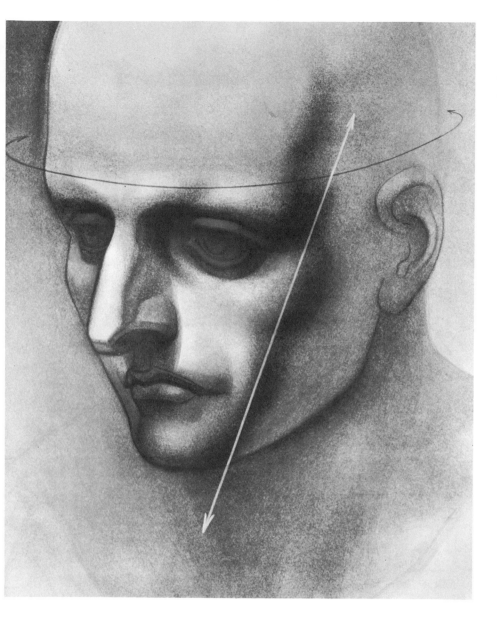

Side Plane

The side plane of the face begins decisively at the *brow point*, just above the outside corner of the eye. Here the front and side planes meet, then fall obliquely inward to the cheek bone, mouth edge, and chin. The line of the side plane lies on a steep 15 degree drop from brow to chin.

ROTATION OF SIDE PLANE

Hard-cornered as the brow point is, the line (A-B) on which it lies is quite *circular*, going around the middle of the head. This curvature means that when the head turns, the side plane of the head (C-D) rotates in the same proportion as the center line (E-F).

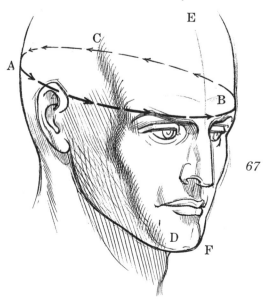

67

PLACEMENT OF SIDE PLANE

To locate the side plane for *any* given turn of the head, follow this simple procedure:

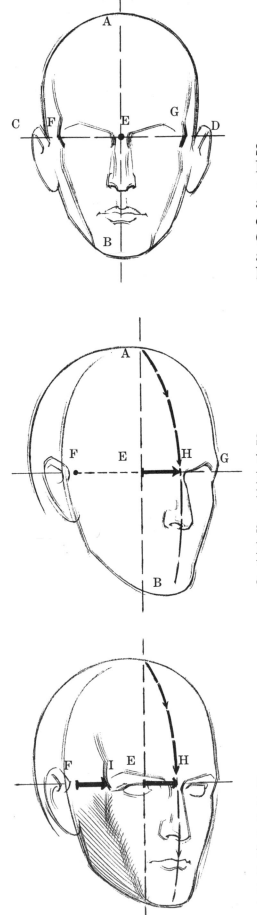

Step 1: Draw a front view head and put in the vertical (A-B) and horizontal (C-D) axes. These axes meet at the center point of the face (E). On the brow line (horizontal axis C-D) indicate the two brow points (F and G).

Step 2: If we give the head a turn to the right, the center point of the face will move from E to H. A new center line (A-H-B) is established. F shows where the left brow point appeared on the front view, step 1. Note the new location of the right brow point (G).

Step 3: The measure E-H represents the amount of rotation of the center point. The rotation of the old left brow point to its new location (F-I) should equal E-H. Beginning at the new brow point (I), complete the 15 degree drop of the entire plane from brow to chin.

FOUR EXAMPLES OF SIDE PLANE PLACEMENT

In these four head views, the side plane is established by first resetting the brow point as demonstrated above. Keep this simple rule in mind: The brow point shifts from the same distance (A to B) as the center facial line shifts from the front to a new position (C to D). In all cases the partitions are held to the line of the brow, whether the line is curved or flat.

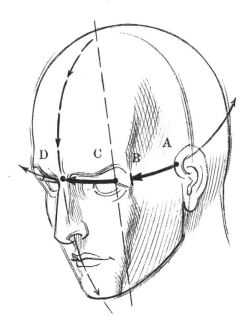

Left Turn, Down View

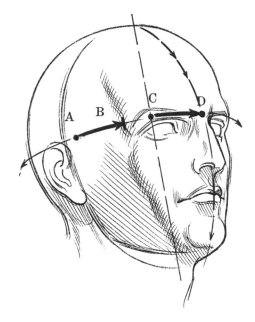

Right Turn, Up View

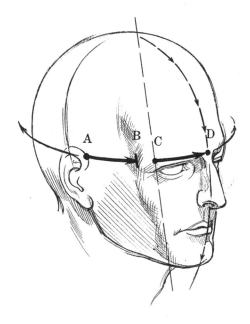

Right Turn, Deeper Down View

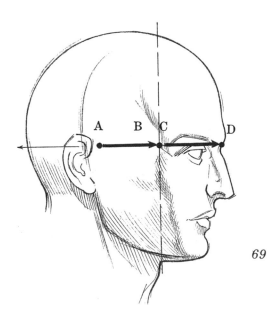

In this view (full turn, right profile) measures A-B and C-D meet at brow point.

69

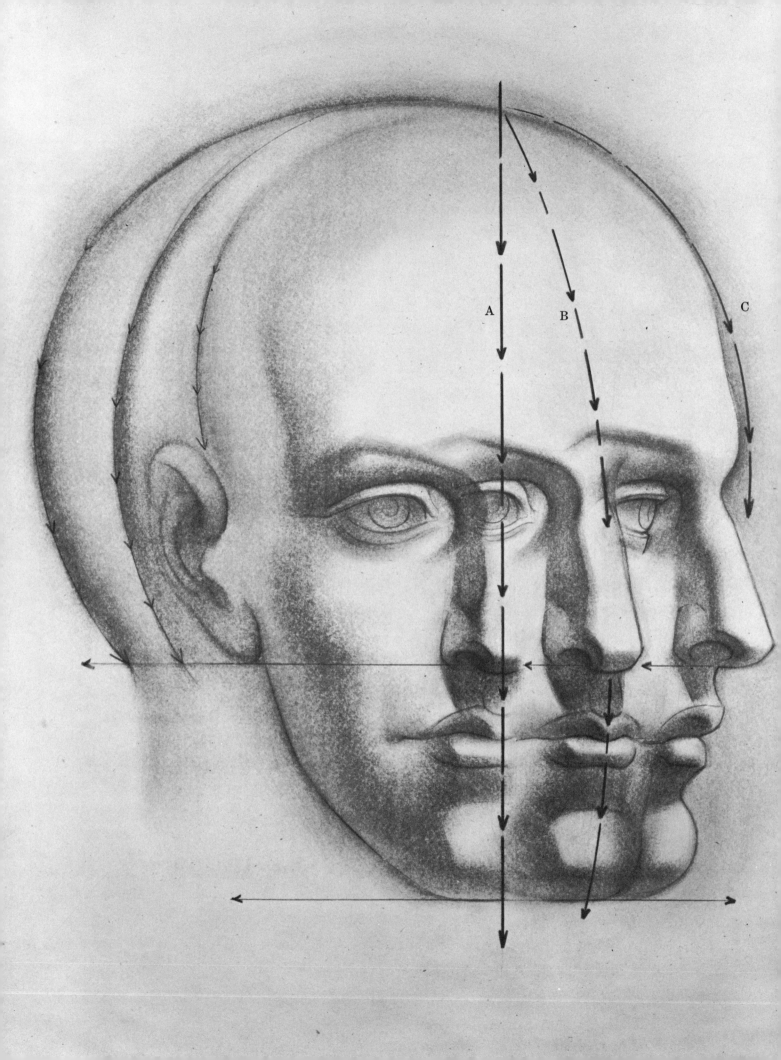

Jaw Line

The jaw line, from *any* view, tends to remain unchanged no matter how the head turns. This means that the edge of the egg shape, when drawn as a front view, will continue to define the jaw line as the head turns. As the head rotates, the jaw line stays where we originally drew it! This seems to be a startling assertion. But observe the jaw outline as the head rotates and you shall see this principle borne out.

RELATION OF SIDE PLANE TO JAW LINE

The jaw contour has this surprising characteristic because of the widespread, flat form of the lower-side-facial area. From the edge of the mouth to the jaw, the surface is quite even and without projections.

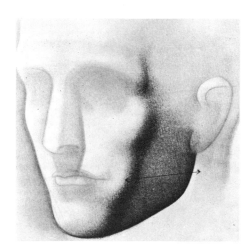

FRONT VIEW

Seen from a front view, the mouth-to-jaw plane (A-B) appears greatly compressed or foreshortened.

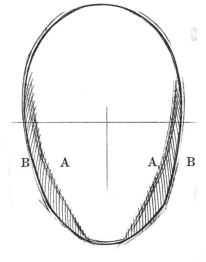

THREE-PHASE ANALYSIS OF JAW LINE

In this three-phase drawing, we see three positions of rotation in one head.

Center line (A) is a front view; center line (B) is a three-quarter view; center line (C) is a side view. In all these views, the jaw line does *not* change. It is constant for all positions. Try seeing each head separately with the jaw line: it is roughly correct for each view of the head.

ANALYSIS OF ROTATION

However, as the head turns, first a little, then more, the side plane of the jaw appears to *expand* and *widen*, like the flat side of a box which reveals more of its side as the box rotates. This *expansion* of the side plane holds the jaw line to a constant position. No matter how much the head turns, the jaw line remains *exactly in the same place*.

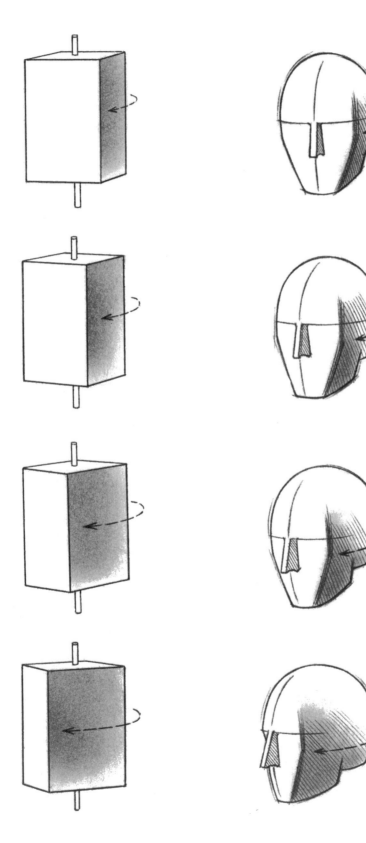

UP AND DOWN MOVEMENT OF HEAD

The brow line, which lies across the middle of the head at the bridge of the nose, is the horizontal axis of the head. Below this line, the facial mass begins. *All up and down movement of the head starts with this line.* If the head tips down, the axis line drops; if the head lifts up, the line rises.

How Movement Affects the Brow Line

The amount of rise or fall of the brow line *off the horizontal position* represents how much curvature the brow arch will show. The brow curvature is reflected in a sequence of similar curves over the entire surface of the head, from top to bottom.

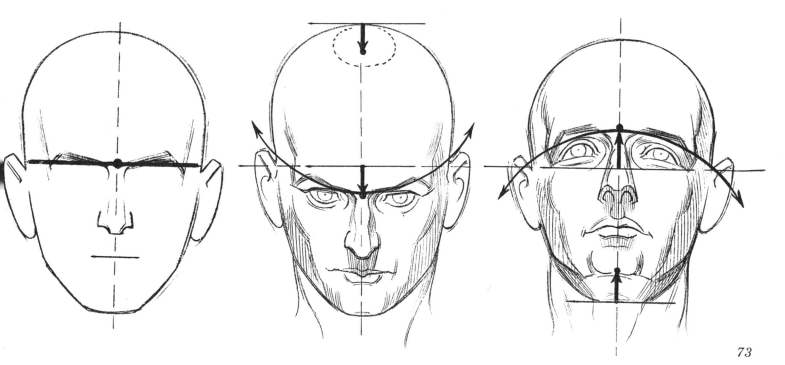

73

BROW LINE AXIS

In a direct frontal view, the brow line axis is a horizontal line.

DOWN VIEW

In a down view, the drop of the brow permits a corresponding drop of the crown. We see the top of the skull.

UP VIEW

In an up view, the rise of the brow gives the chin base a corresponding lift. We see the under plane of the jaw.

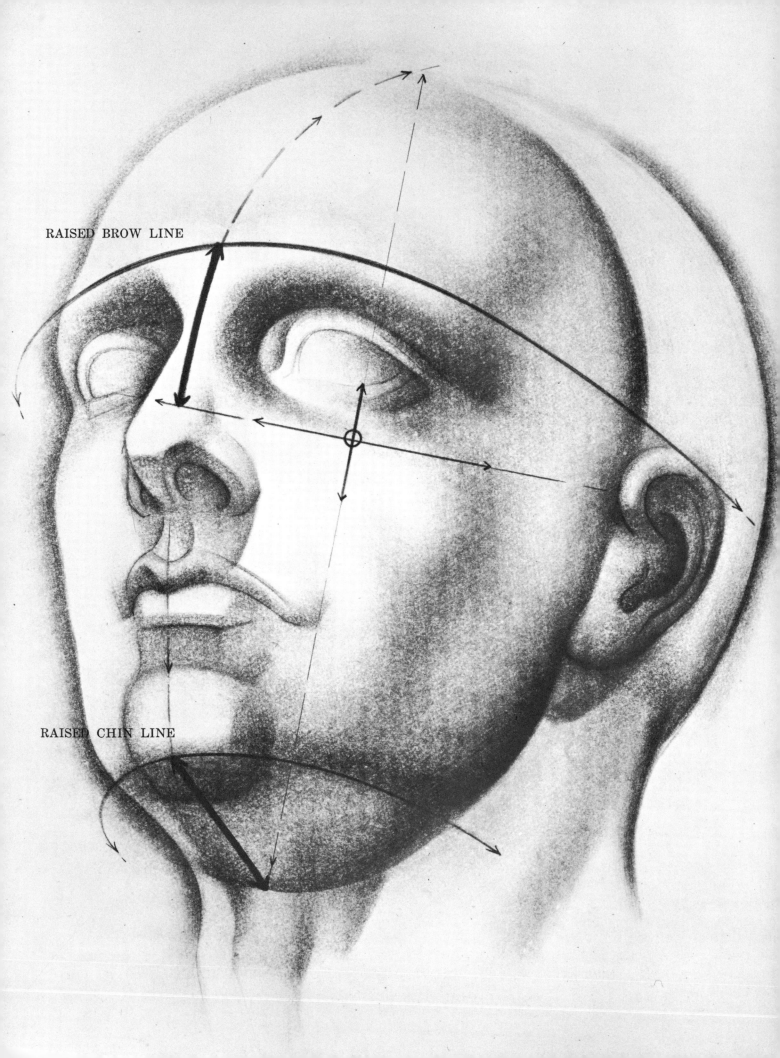

RAISED BROW LINE

RAISED CHIN LINE

Ear Placement

When the head moves up and down, special care must be given to the placement of the ear. The ear always goes in an opposite direction to the facial tilt. When the face is down, the ear is up; when the face is up, the ear is down. This rule also applies to the skull base.

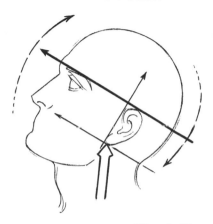

Head Up

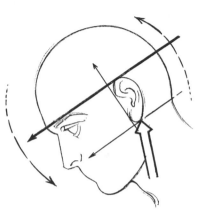

Head Down

METHOD OF PLACEMENT

To place the ear on a tilted head, set up two track lines: the first from the brow corner; the second from the nose base. Swing these tracks as the brow *axis line* indicates, curving down or up as the head position demands. Place the ear *within* the tracks, fixed to the jaw line. The skull base aligns with the ear base.

HREE-QUARTER UP VIEW

f the head is seen from an extremely low angle, the brow urve takes on an extremely rched appearance. This qual- :y also appears in the jaw base nd smaller features like the nouth, lips, and chin. Note ow the *amount of rise* of the row curve determines the rise f the chin base.

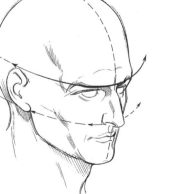

Face down: ear appears high in this view.

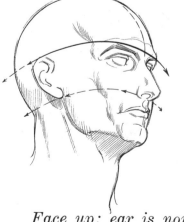

Face up: ear is now very low.

75

Checking Proportions and Placement

Once the ear is properly placed on the head, we must check the remaining features of the face for accurate placement and proportions. The following points are offered as a check list for up views and down views of the head.

BASE OF NOSE

The *base* of the nose is one eye-length wide. Check the eye with the nose width for accuracy.

EYE PLACEMENT

To place the eye correctly in its socket, draw a line upward from the edge of the nostril wing to the brow. The inside corner of the eye starts from this line.

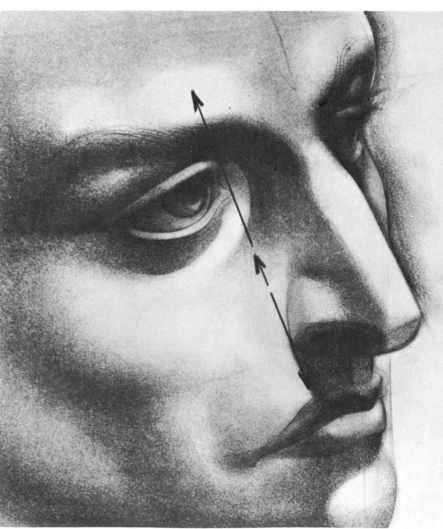

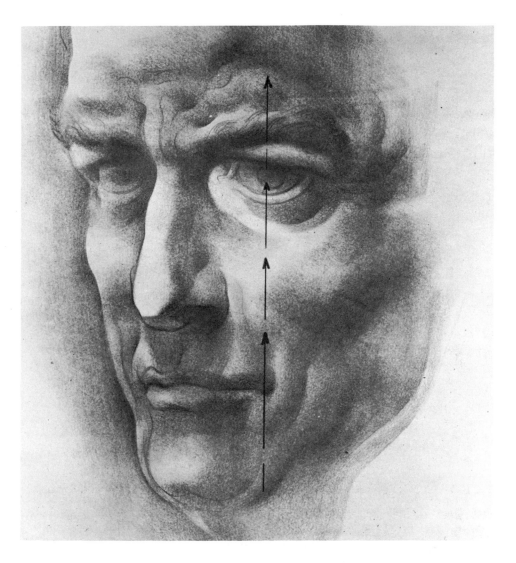

MOUTH AND CHIN

The corner of the mouth holds to a line drawn down from the center of the eye. This line also identifies the side of the chin.

JAW CORNER

The jaw corner lines up with the opening of the mouth and the lower lip. In three-quarter up and down views, this corner lies on a 45 degree line that starts at the nose bridge and curves across the face.

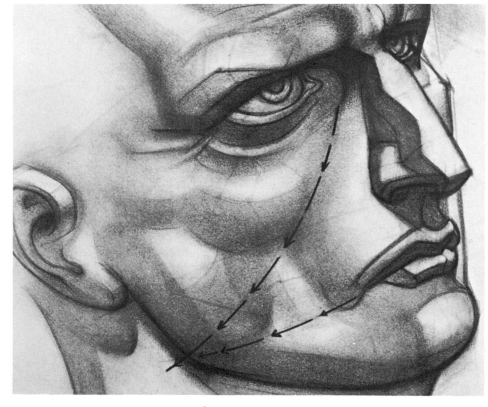

77

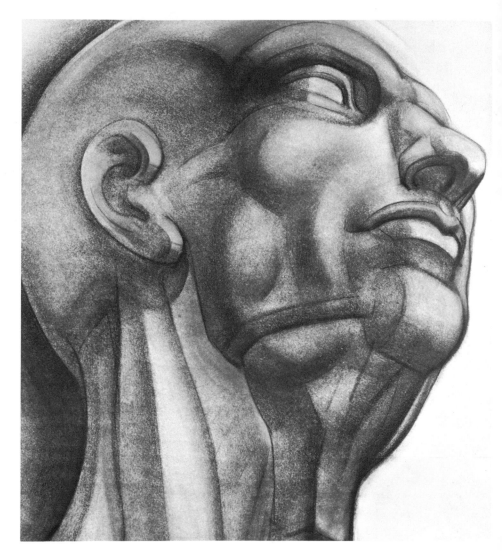

UNDER-JAW

Seen from below, the muscle mass connecting the chin to the neck slopes down at a 15 degree angle. Its form looks like a wide funnel-opening thrust into the horseshoe form of the lower jaw.

EYE FORM

The eye, in upshot and down-shot, shows two remarkably different curves. Here, when the eye is seen from above, the lower lid curve is round, while the upper lid is hardly curved, *almost* a straight line. When the eye is seen from below (see facing page), the appearance is reversed. The upper lid is greatly curved, and the lower lid is flat.

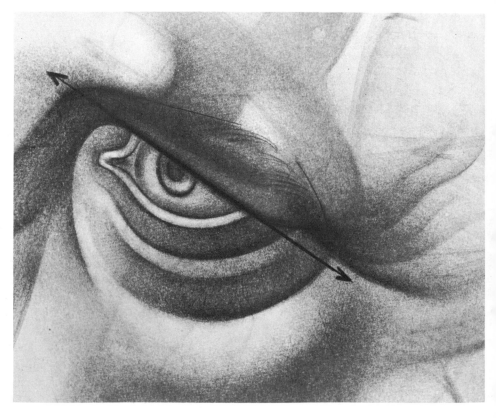

EYE PUPILS

Study the pupils of the eyes, both in up and down views, and in rotating views of the head. In these positions, the eye pupil disc is an *ellipse*, a circle in perspective. In a *front* view, when the eye moves up or down, the ellipse is *horizontal:* shallow from top to bottom. In a partial side view, the ellipse is *vertical:* shallow from left to right.

Up view: pupil is horizontal ellipse.

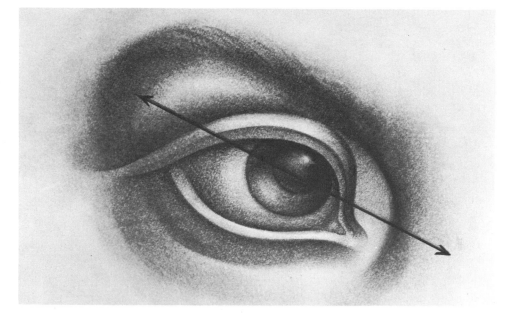

Down view: pupil is horizontal ellipse.

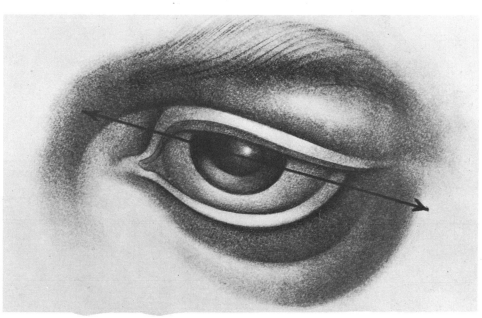

Partial side view: pupil is vertical ellipse.

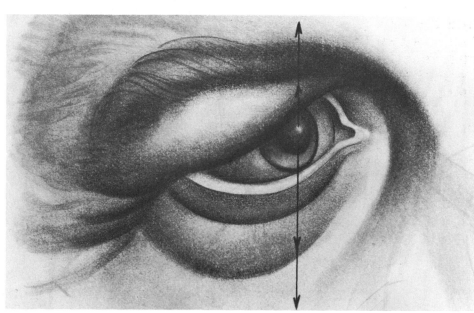

79

EXTREME HIGH AND LOW VIEWS

Seen from an *extremely high* or *low* position, the great ovoid form of the cranial mass dominates the shape of the head. The irregular facial forms tend to become subordinate to the spherical brain case.

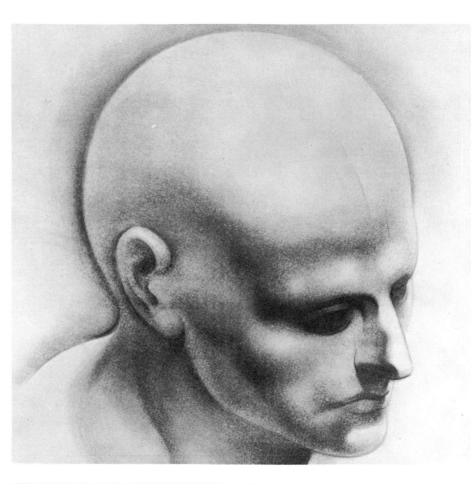

Extreme Down View

Extreme Up View

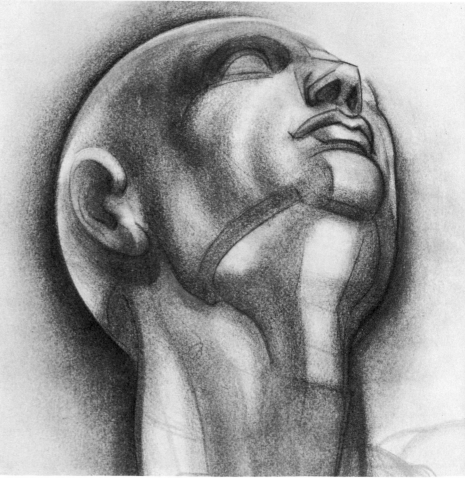

VOICE BOX (ADAM'S APPLE)

When the head moves in *any* direction, you can locate the voice box by drawing a line from the center of the nose through the center of the lips. Moving downward, the line strikes the voice box in the center of the neck.

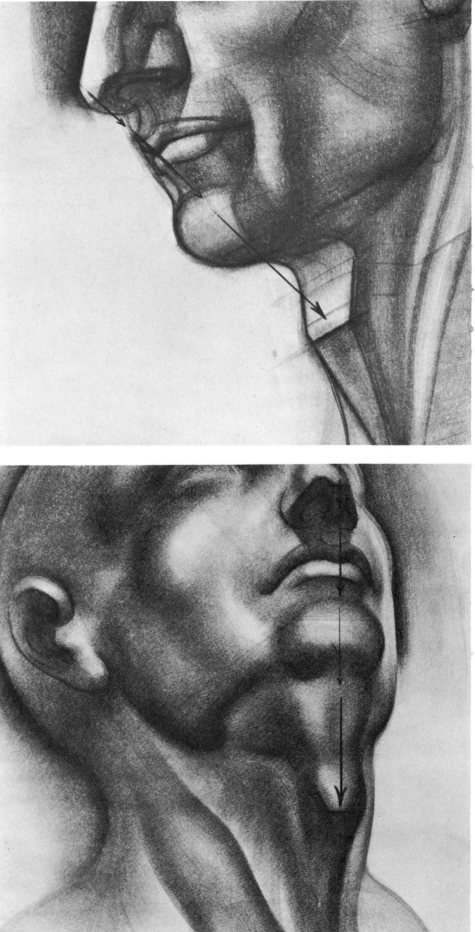

Upshot Side View, Left: Finding Center of Neck.

NECK COLUMN

The neck column, curving backward in a long arc, may then be added from the skull base.

Extreme Three-Quarter Up View, Right: Finding Center of Neck.

81

3.
Facial
Change:
Wrinkles

In Chapters 1 and 2, the head has been seen as a standard, generalized structure. The discussion has been limited to *averages* and *similarities* of all heads. We shall now proceed to the factors which determine facial *differences*. In the next two chapters, we shall explore two forms of facial change: wrinkling and aging.

THREE WRINKLE PATTERNS

Wrinkling of the face occurs for a variety of reasons. The most common reasons relate to incidental facial activity, such as chewing, grimacing, winking, pouting, squinting, expressions of pleasure and distaste, and demonstrations of emotion. Other reasons relate to psychological stress and inner tensions, as well as aging, muscular flaccidity, or loss of firmness in flesh. Whatever the origin of wrinkles, their development follows three major patterns: frontal, oblique, and lateral.

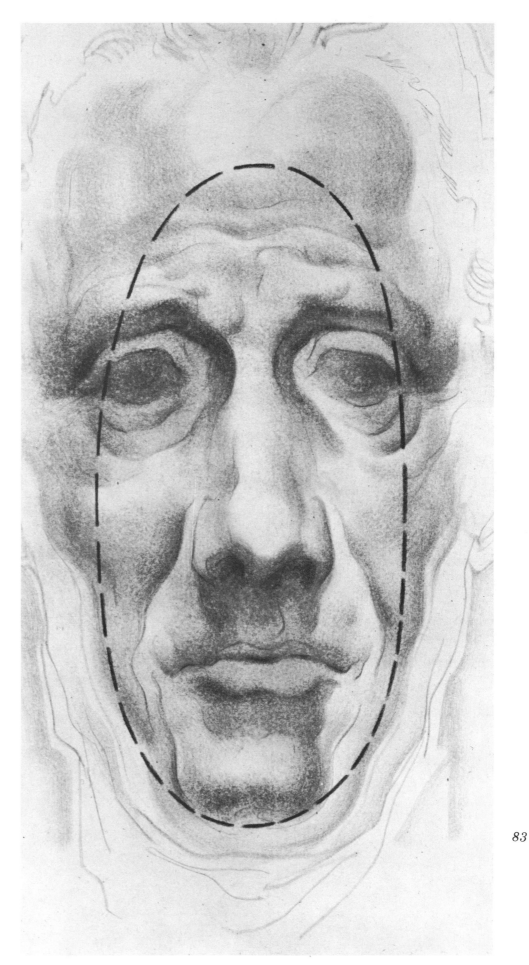

Frontal Pattern

The *frontal pattern* of wrinkles is heavily concentrated in the central region of the face. This pattern has its root in the nose bridge, and at the base.

NOSE BRIDGE

At the bridge, the frontal pattern starts with a deep horizontal groove across the root of the nose, accompanied by an intense inward compression of the eyebrows. As the eyebrows compress, vertical furrows rise in the center of the brow arch, swing slightly out, then close in an elliptical curve at the base of the forehead. As the eyebrows collide, the skin folds seem to squeeze or crush. Note the *upward* movement of the frontal pattern, high in the nose.

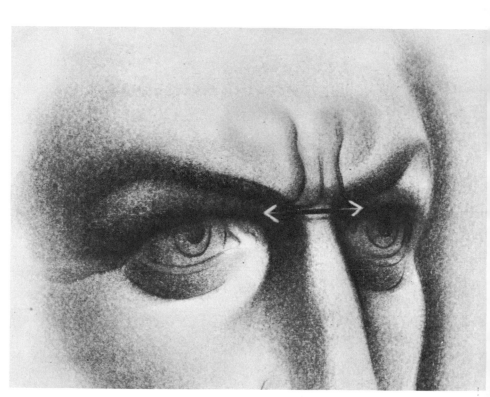

Horizontal Groove

Vertical Furrows

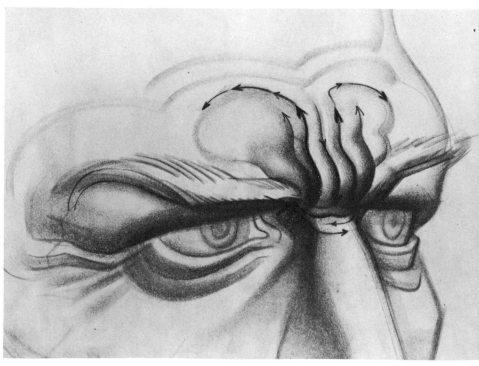

84

NOSE BASE

At the base of the nose, two wrinkle movements occur: one thrusts upward to the nostril wings; the other drags downward to the mouth and chin. These movements are largely vertical.

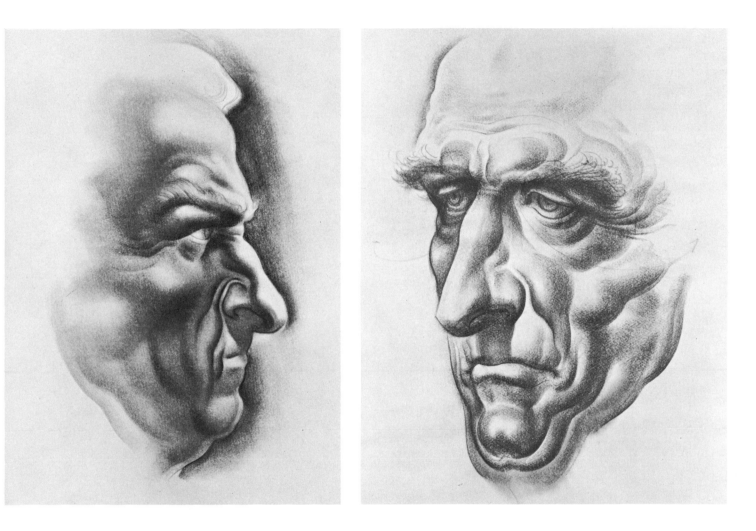

UPWARD MOVEMENT

The upward thrust from the nose base produces a sharp curling of the flesh around the nostril wings. The action is high and arched. The upper lip is pulled upward from the center. The nose tip, while it does not move, takes on a forced, outthrust appearance. The effect is like an expression of distaste.

DOWNWARD MOVEMENT

The downward movement begins lightly around the nostril wings. From here, a deep channel emerges and swings around the mouth bulge, then closes in a tight curve, circling the frontal prominence of the chin. The lower lip is forced out when the mouth is closed.

Oblique Pattern

The oblique pattern of wrinkles develops above and below the inside curve of the eye socket, and the inner contour of the cheek bone. The oblique pattern belongs to the inner eye, the brow, and the cheek bone, as the frontal pattern belongs to the nose, the mouth, and the chin. The oblique pattern lies adjacent to the frontal pattern. Its main directions are angular and outward. It moves both up and down.

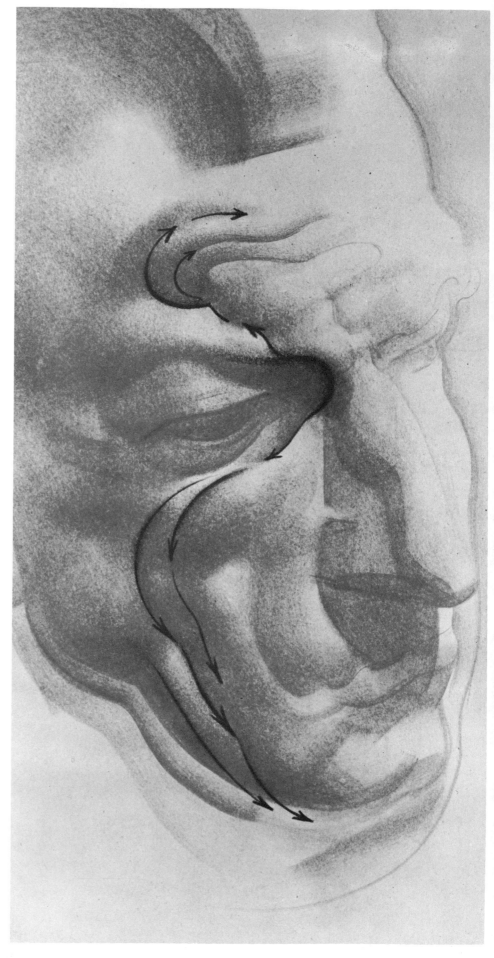

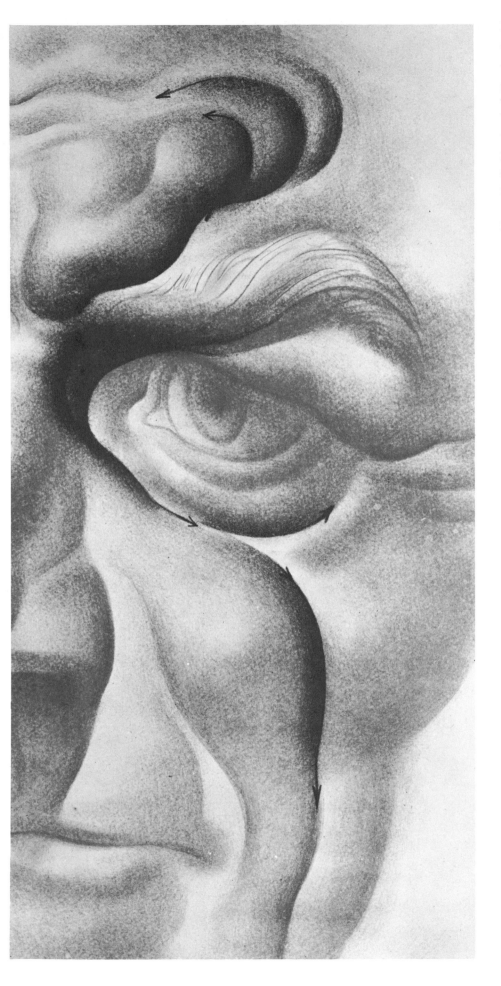

PATTERN BEGINS AT EYE

The oblique pattern begins in the deep inner curve of the eye socket below the nose root. Two wrinkle movements develop: below, a depressed ring edges the socket and lower eye and moves downward over the cheek; above, the pattern moves from the socket curve over the mid-brow to the base of the forehead.

87

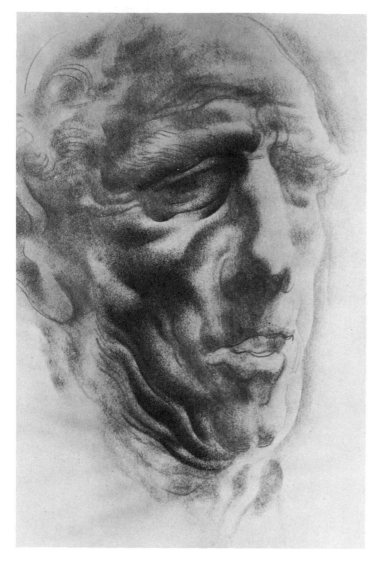

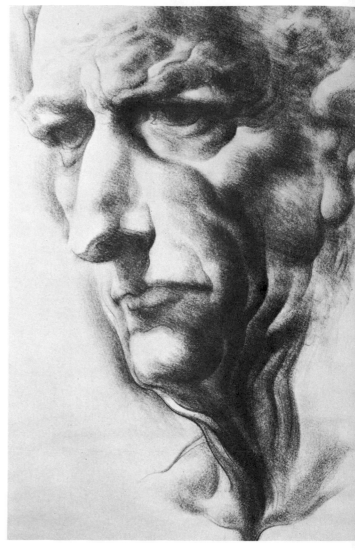

CHEEK

The oblique pattern descends across the cheek. Decisive rifts appear. In aged persons, the cheek bone is exposed, with a hollow below.

JAW AND NECK

The downward movement continues across the middle of the jaw and its undersurface, then cascades in fleshy channels down the side of the neck to the protruding collar bones.

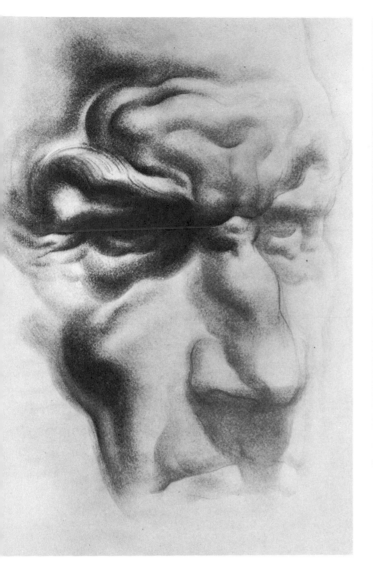

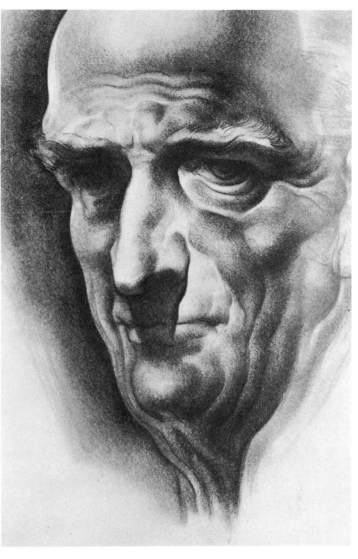

ASCENDING MOVEMENT

The wrinkles rise from the compression line of the eyebrow and inner socket. Then they range up and outward in an arc that curves around the mid-brow. The movement turns and ends in a series of horizontal rifts across the lower forehead.

ZIG-ZAG MOVEMENT

The oblique pattern is like a *zig-zag* movement up and down the face, starting at the inner curve of the eye socket.

89

Lateral Pattern

The lateral pattern consists of all the wrinkles on the side region of the face, neck, and back of the head. This diffuse pattern shows isolated furrows and rifts which emanate from the outer eye, ear, jaw line, and back of the neck below the skull base.

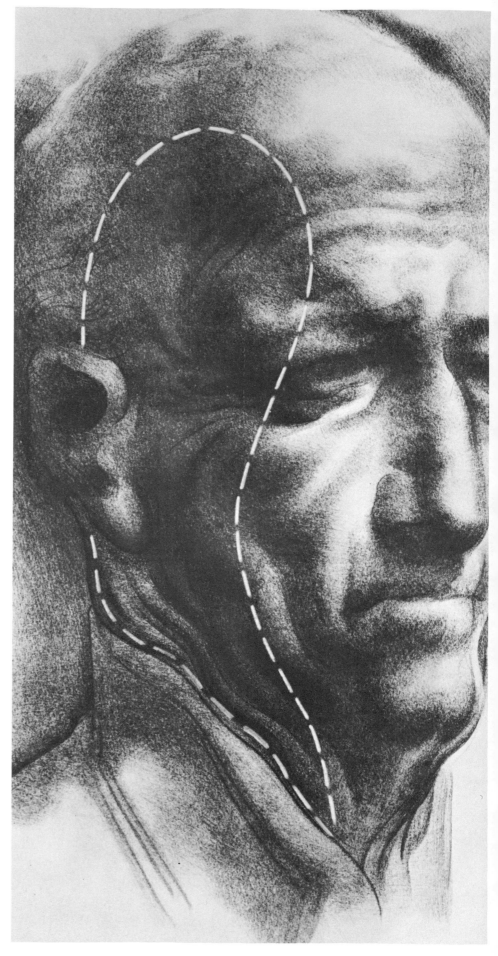

CROW'S FEET

The fan-like wrinkles which start at the outer corner of the eye are commonly called *crow's feet*.

As the eyelids terminate, a series of creases fan out from the socket, wheel upward around the brow corner and across to the ear, and spread downward to the cheek bone arch.

SIDE VIEW OF CROW'S FEET

From a side view, the crow's feet show a radiating effect. Near the eye corner, the wrinkles are deeply creased. As they flare outward, they split into finer, less decisive wrinkles, especially on the side of the forehead and cheek.

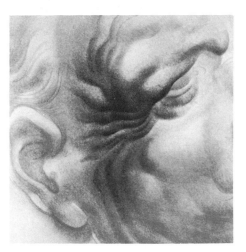

EAR

The wrinkles which develop around the ear merge with those of the jaw line and neck. At the forward edge of the ear, slight rifts curl around the rim; slip down to the lobe; then descend to a series of furrows cutting the line of the jaw. These move on to the under-jaw and neck, becoming deeper fleshy channels. From the rear of the neck below the ear, corrugations move down to meet the jaw wrinkles, flowing down together toward the neck base. The ear is like an island dividing a flowing stream.

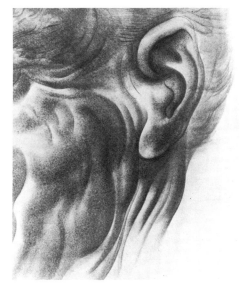

91

TENSION AND PRESSURE WRINKLES

Wrinkles tend to develop in the skin which covers the *crevices* and *recessed regions* of the head and face. In these places, rifts, creases, and folds appear when the skin responds to some movement of the head, jaw, or facial muscles. For instance, wrinkles occur when we laugh, frown, sneeze, squint, wink, tilt or swing the head. The pull of muscles causes *tension wrinkles*. The contraction or squeeze of muscles causes *pressure wrinkles*.

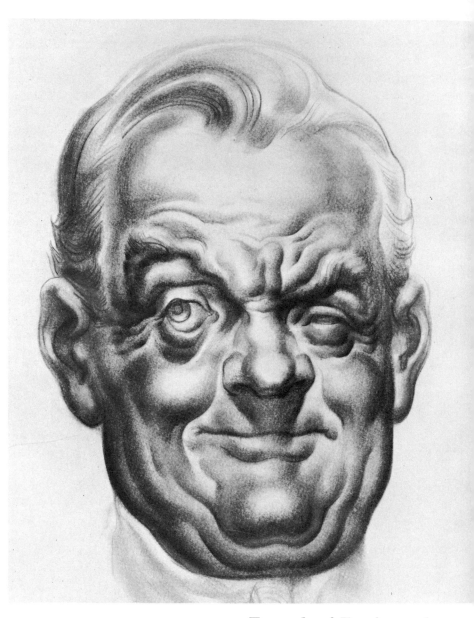

Example of Tension and Pressure Wrinkles

The skin creases when thrusts develop from the action of eyebrows, eyes, cheeks, and mouth. Creases under the chin and jaw are forced by the tilt and inward pull of the head.

SAG AND SHRINKAGE WRINKLES

Another variety of wrinkles occurs as a result of the aging of the skin and fleshy fibers of the head. The flesh loosens and the skin shrivels; the tissues lose their firmness and elasticity. This creates what we may call *sag and shrinkage wrinkles*. These tend to be random and unpredictable. Sag wrinkles are usually loose or flaccid, taking a downward course, as they are pulled by the force of gravity. Shrinkage wrinkles look dried out and withered in the heavier, thicker tissues of the face; a shrunken and cross-grained effect may be seen, for example, on the lips, chin, cheeks, and ear lobes of aged persons.

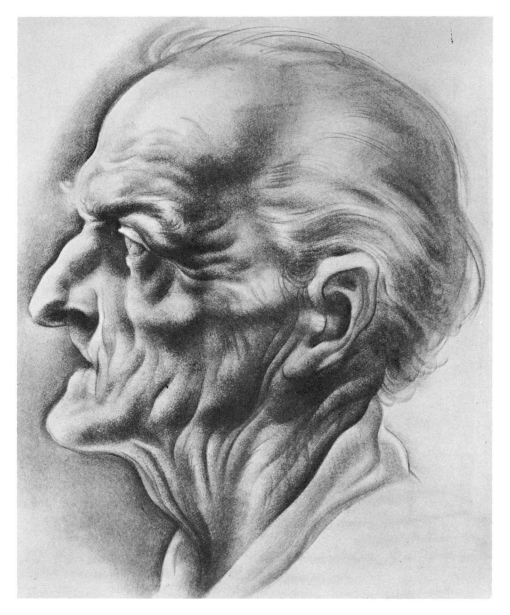

Example of Sag and Shrinkage Wrinkles

Note the sag of the loose, hanging folds below the chin and jaw. Shrinkage may be seen on the brow, cheek, lips, and back of the neck. Note the cross-grained, shriveled appearance.

INTERACTION OF WRINKLE PATTERNS

The three major wrinkle patterns interact: they are not independent or compartmentalized. In these four examples, observe the groupings and then draw your own examples from persons near at hand. Observe the tension and pressure wrinkles, and the sag and shrinkage wrinkles.

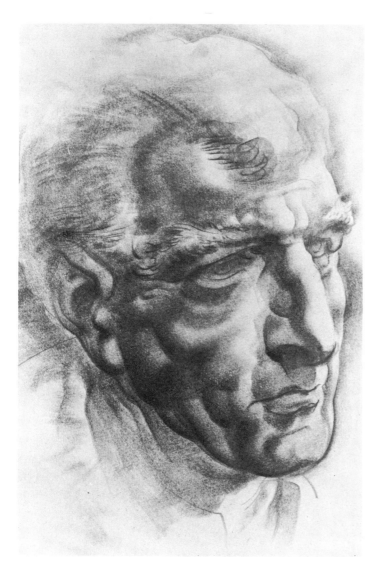

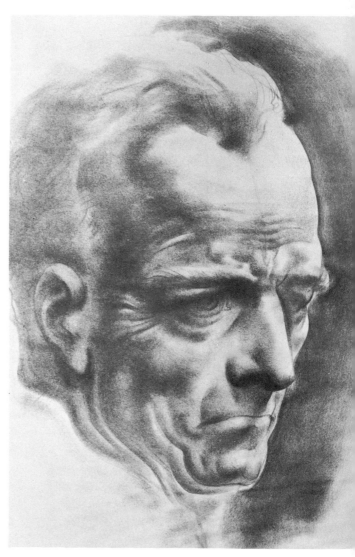

Parallel Effect of Pressure and Tension

An expression of concentration causes pressure wrinkles to appear between the eyebrows. At the same time, incipient tension folds develop on the side of the mouth and cheek.

Pressure Reaction to Head Thrust

When the head is thrust forcefully into the neck, extreme pressure creases girdle the entire perimeter of the lower jaw and chin.

pposition of Tension nd Sag Wrinkles

ere we see two contrary tendencies. The upward pull of ie eyebrows reveals tension rinkles on the forehead, hile the neck region expresses n over-all downward drift of ig wrinkles. Note further the ibtle shrinkage creases on the ps of this older woman.

Contrary Effect of Pressure Rifts

The retracted mouth produces tension in the lips and chin. At the same time, a severe contraction (pressure) in the brow and nose bridge effects an opposite pressure on the nose above the nostril wing.

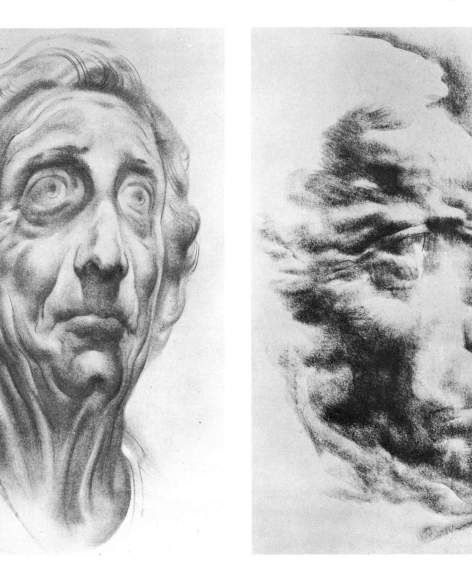

4.
Facial Change: Aging

As the head ages, changes take place in head proportion, skull development, and bone articulation in brow, nose, jaw, and teeth. Growth in flesh, tissue, skin, lips, ears, eyelids, and hair all contribute to the descriptive aspects of aging. Less obvious, but no less important, are changing head positions, body attitudes, and gestures; these add subtlety and distinction to the head in growth, maturity, and decline. The following sequence of illustrations will analyze the progressive aging of the head, as form and detail change year by year.

AT BIRTH ▶

Proportion: facial mass, 1 part; cranial mass, 3½ parts. Forehead and nose meet in continuous S-curve. Ear quite large, set forward toward face. Jaw short; flat, undeveloped jaw angle. Nose appears large, compared to mouth and chin. Eye closed; has compressed, bulged appearance. Sparse, downy hair (but occasionally profuse) covers head from crown backward. Short neck; appears feeble and weak.

MONTHS ▶

Proportion: facial mass, 1 part; cranial mass, 3 parts. Facial mass fuller; jaw slightly increased. Nose appears smaller. Note roundness of cheek, chin, and neck. Mouth tends to be full, curved, open. Hair longer, fine, feathery. Eye alert, responsive.

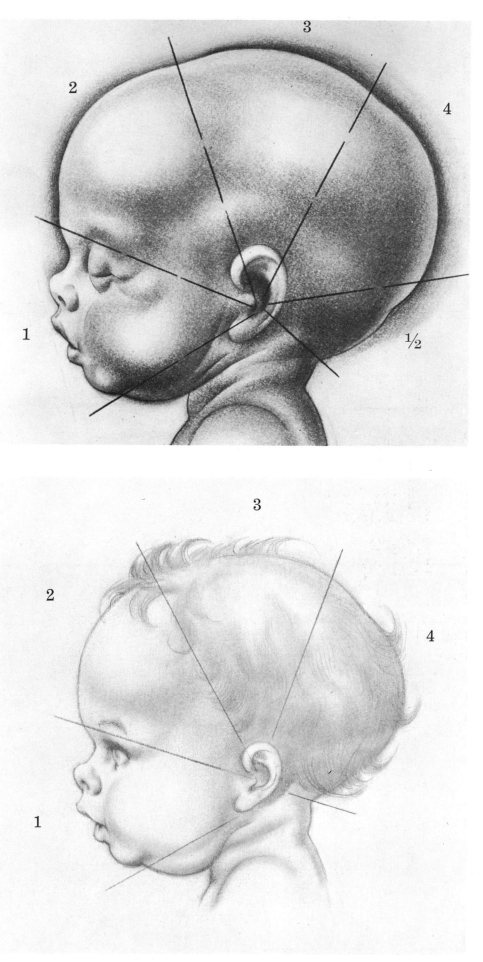

1 YEAR

Proportion: facial mass, 1 part; cranial mass, just *under* 3 parts. Pronounced S-curve of forehead and nose. Eye, mouth, and lips active and eager. Chin, cheek and neck fat developed; chubby appearance. Neck somewhat longer.

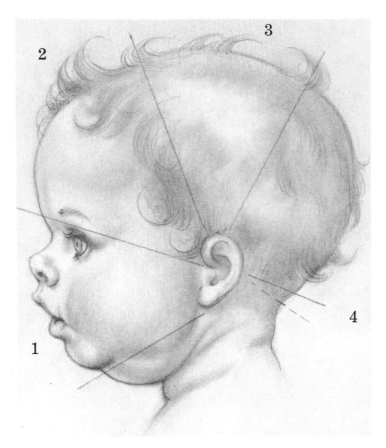

2 YEARS

Proportion: facial mass (still increasing), 1 part; cranial mass, 2¾ parts. S-curve of forehead and nose maintained. Small, short nose. Hair thicker and profuse. Jaw and chin more developed; cheek, jaw and neck fat evident. Mouth soft and curved, but firmer and more controlled. Neck somewhat longer.

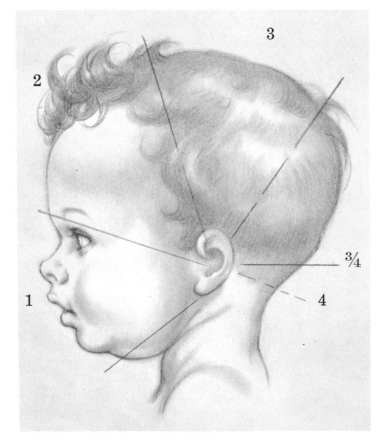

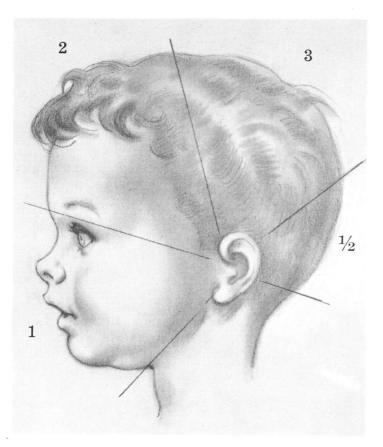

3½-4 YEARS

Proportion: facial mass (still increasing), 1 part; cranial mass, 2½ parts. S-curve of forehead and nose persists. Nose slightly longer. Cheek full and rounded. Jaw larger; chin curved, somewhat prominent. Under-jaw fat and neck fat disappearing; neck longer. Lips firmer; mouth more competent and expressive.

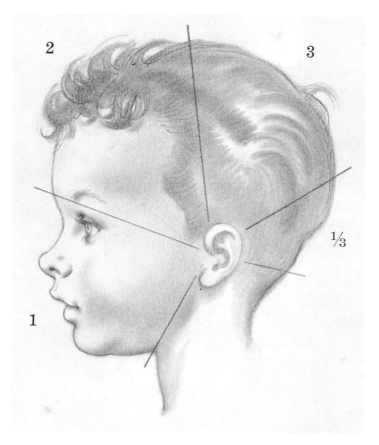

6-7 YEARS

Proportion; facial mass (still increasing), 1 part; cranial mass, 2⅓ parts. Orbits almost as large as adult. Nose still curved, but longer; tip up-thrust. Mouth region larger. Chin round, more prominent; jaw angle more vertical; jaw larger. Neck longer. S-curve of rear head bulge and neck evident. Hair unruly, thicker, more adult.

8-9 YEARS

Proportion: facial mass (still increasing), 1 part, cranial mass, 2¼ parts. Forehead changed somewhat; brow arch showing, nose bridge deepening. Nose longer, more developed, but still curved; tip upthrust. Lips still curved; mouth region increased. Jaw leaner; chin longer, more pointed, but still rounded. Neck longer. S-curve of head bulge and neck maintained.

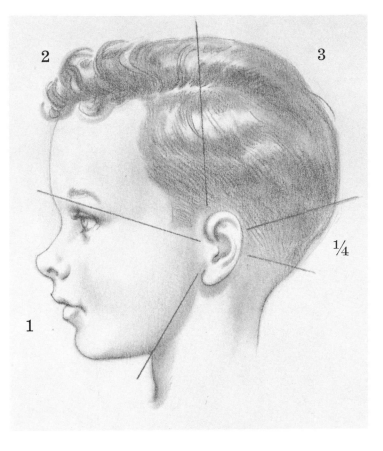

11-12 YEARS

Proportion: facial mass, 1 part; cranial mass, almost 2 parts. Head somewhat smaller than adult, but mature ratio appears. Brow bulge and nose bridge more apparent. Nose longer, more articulated; tip still up. Mouth firmer; chin larger; jaw heavier and broader. Adam's apple puts in slight appearance (voice change beginning). Neck longer and slightly thicker.

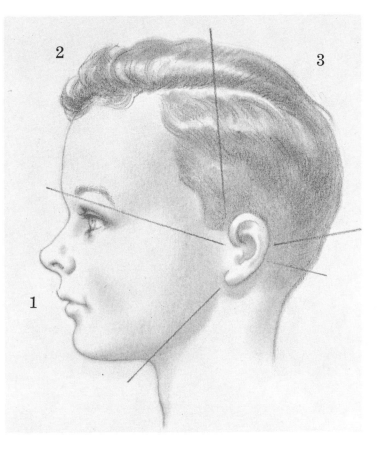

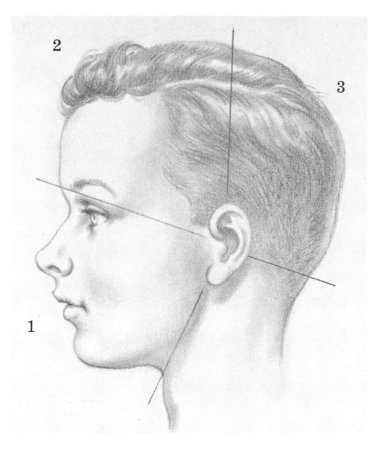

14-15 YEARS

Proportion: mature level reached; facial mass, 1 part, cranial mass, 2 parts. *From here on, head proportion continues at this ratio.* Brow thicker. Nose bridge deepens. Nose tip still up. Jaw corner more angular; chin firmer, less rounded. Adam's apple more pronounced. Neck longer, a bit heavier. Back head bulge still present, still immature.

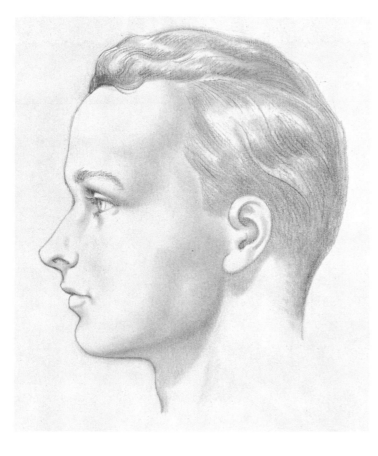

18-20 YEARS

Young adult stage achieved. Understructure of head comes through; leaner facial appearance. Cheek softness disappears. Deeper nose bridge; nose tip less evident. Jaw angle firm. Mouth more firm; lip softness disappears. Neck muscles stronger, more developed. Skin texture firmer, thicker.

25 YEARS

Deep nose bridge; nasal bone more pronounced. Lean cheek and cheek bone. Chin mound more decisive; under-jaw region firm and even. Mouth more reserved.

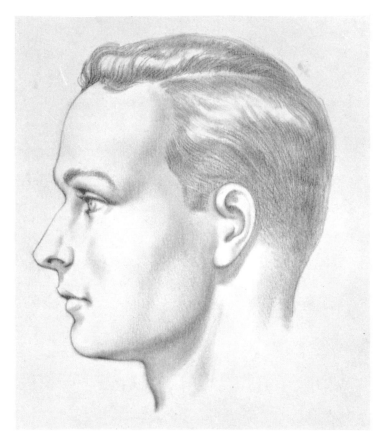

30 YEARS

Eye appearance deeper set, searching, incisive. Early development of creasing, starting at outer corner of eye and forehead. Mouth, chin mound, and jaw line firm. Slight fleshiness under-jaw.

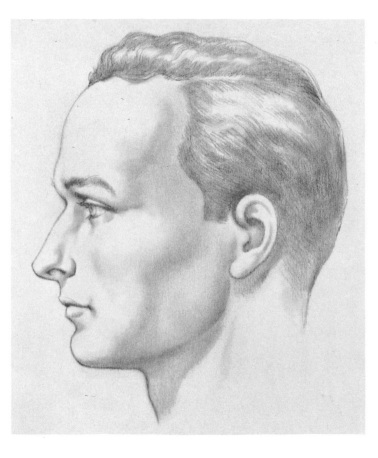

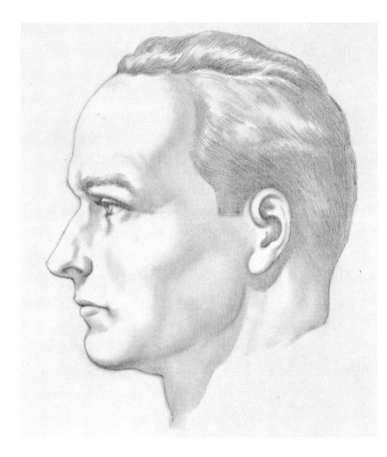

35 YEARS

First appearance of softness and fleshiness under jaw; chin mound cleavage occurs. Mouth wrinkle emerges. Under eye sag; further increase of eye and brow wrinkles. Neck less lean, somewhat heavier. More reserved, less intense facial aspect and bearing.

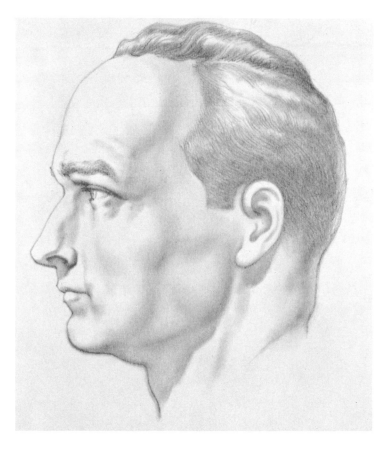

40 YEARS

Hair somewhat thinner. Deeper-set eye; eye socket shows more clearly. Forehead and eye wrinkles advance. Mouth crease more pronounced. Chin mound tighter, less rounded. Under-jaw sag advances; chin shows clear separation from jaw. Neck heavier. Slight fleshy roll at back of neck.

45 YEARS

Hair thinner, graying and receding at temples. Definite crow's feet wrinkle group forming at outer corner of eye. Under-chin sag droops slightly toward neck. Chin mound quite distinct. Jaw corner fleshy, less lean. Neck less firm; early wrinkles starting on side; flesh on rear neck reflects increased body weight.

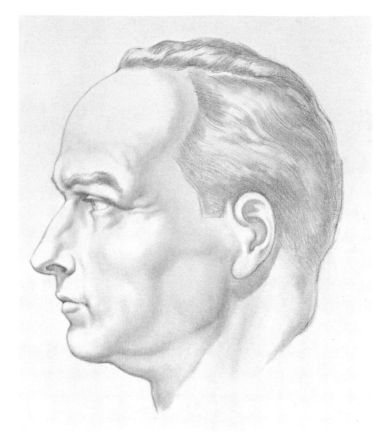

50 YEARS

Frontal hair thinned out; side hair recessed. Grayness continues. Upper lid line sags. Eye deeper-set in socket. Fleshy pouch beginning under lower lid. Wrinkles in mid-forehead. Deeper nose bridge. Cheek flesh sags; cheek bone evident. Secondary sag appears at side of chin. Soft flesh under-jaw sinks toward neck. Jaw line fleshy and unclear. Neck wrinkles increase.

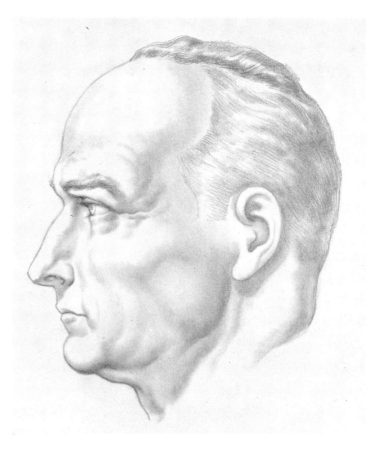

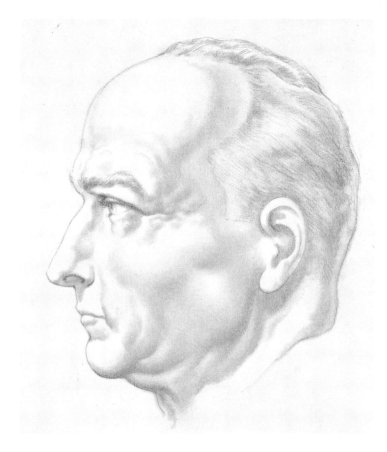

55 YEARS

Hair quite thin on crown; generally gray. Under-eye pouch more decisive. Cheek bone and zygomatic arch apparent. Temporal wall and brow corner pronounced. Chin mound more angular. Back neck fold deeper; front of neck shows sagging, folding, and shrinkage.

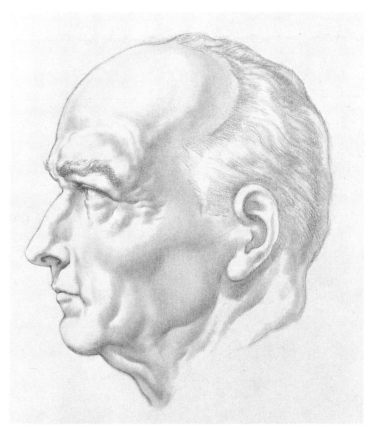

60 YEARS

Cranium generally bald. Bony features of skull apparent throughout. Eye takes on grave, concentrated look. Nose forms more distinct. Lower facial region (especially chin, jaw, and neck) appears slack, flaccid. Ear less firm; shrinkage of forms evident. Facial expression shows tiredness, less energy.

65 YEARS

General flesh and bone shrinkage; hollows and recesses of skull become clear. Folds and creases deepen around mouth, jaw, and neck. Fatigue appears in eyebrow, eye and forehead wrinkles. Eyebrow hair somewhat profuse and unruly looking. Placement of head on neck reflects slightly stooped, less erect body posture.

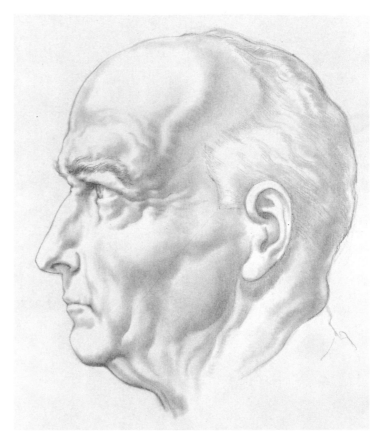

70 YEARS

Tooth loss causes jaw shrinkage; jaw angle less steep. Chin more prominent. Nose seems enlarged. Mouth folds deeper, more extreme; lips appear tighter, more compressed. Obvious hair growth on ears. Scalp hair finer and lank; loses coarseness and vigor. Network of smaller wrinkles develops throughout head. Placement of head on neck reflects increasing stoop of body.

106

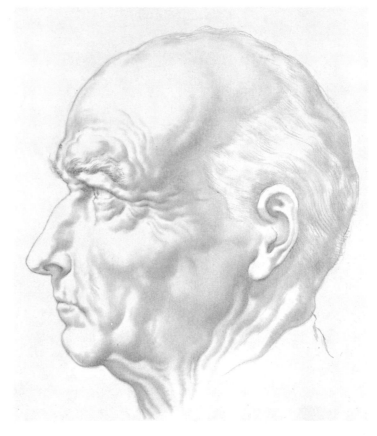

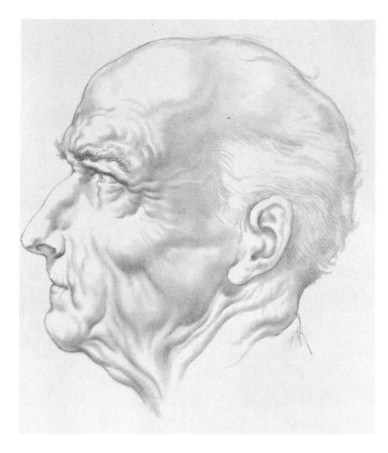

75 YEARS

Loss of teeth; further gum and jaw shrinkage. Chin less fleshy, thrust further forward. Crosscut wrinkles emerge on shrinking lips. Substructure of skull emerges from below skin. Head tends to hang forward in walking; balanced backward while sitting. General weariness in facial expression.

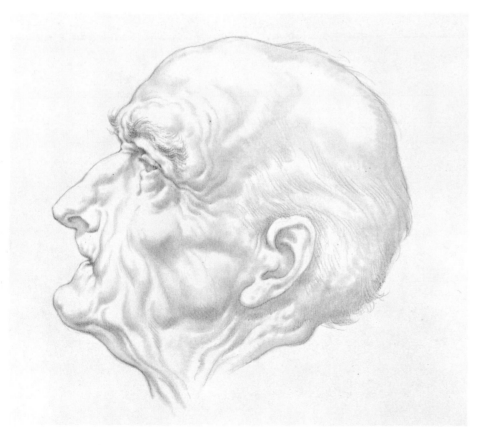

80 YEARS

Senescence and debility overtake head from this stage and beyond. Loss of teeth creates undershot bony look of jaw. Jaw angle quite low and flat. Mouth collapsed and wrinkled. Cheek sunken. Flesh withered throughout the head, including ear and neck. Hair fine, thin, silky. Deep sag on upper lid line; upper eyelid droops markedly. Generally feeble appearance.

5.
Head
Types

We have studied some factors of head structure and facial change common to all members of the human family. People the world over are *generally* alike. But we must recognize that there are enormous variations in detail: there are divergent head types, races, and populations, as well as varied culture groups, and an infinite diversity of individual faces.

THREE TYPES OF HEADS

Among the peoples of the earth, there are three different head types. These are broadly classified according to the *cephalic index*, an established standard of head measurement.

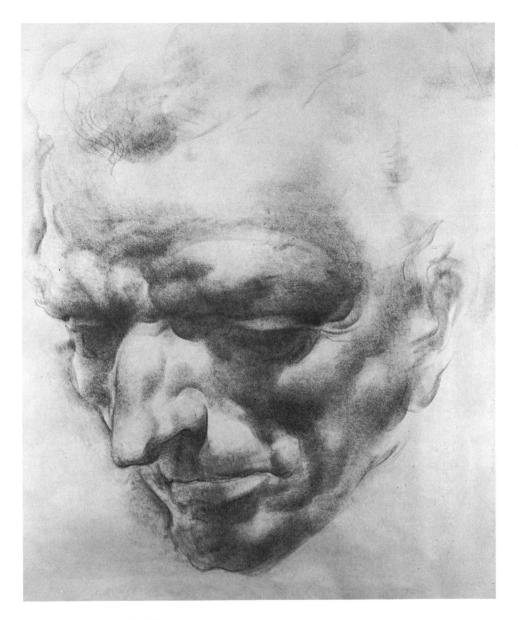

BROAD-HEADED (BRACHYCEPHALIC)

Heads in this category are characterized by a wide skull, yet features and facial aspects may be remarkably varied.

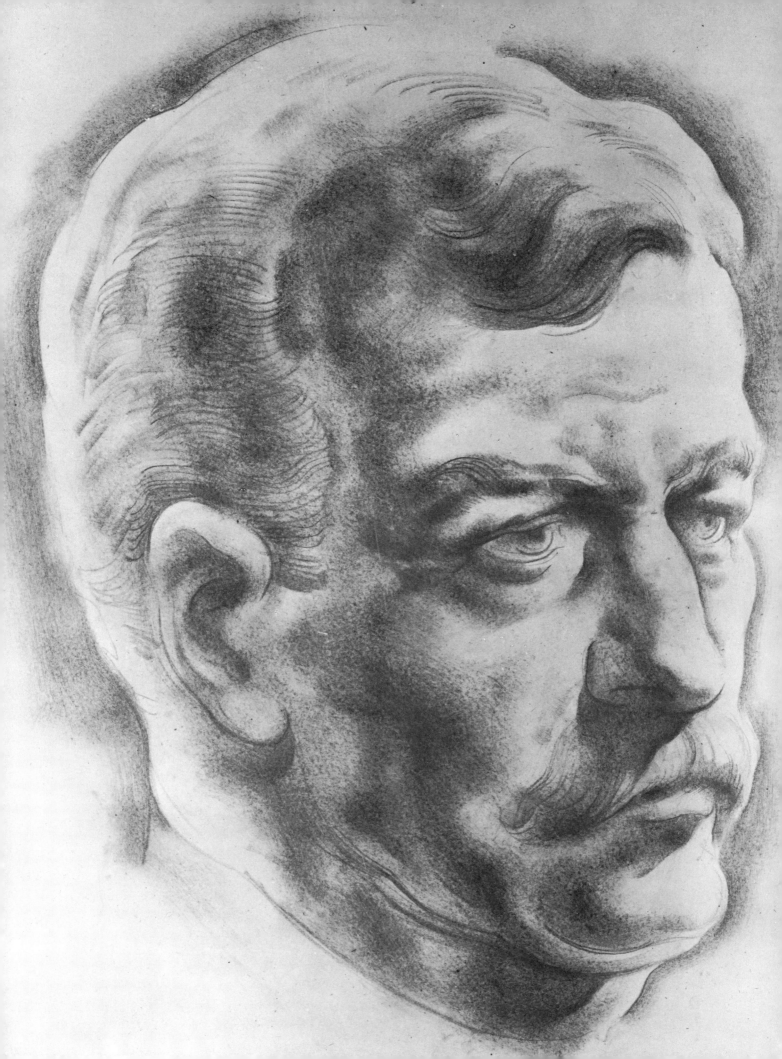

Applying Proportions in Drawing

In drawing this type—or any other—do *not* try to apply the proportions exactly. The drawing is apt to become forced and stilted. If the head is visually *convincing*—even if the proportions are not exact—you have produced an acceptable solution. See how these three examples of broad heads prove this contention.

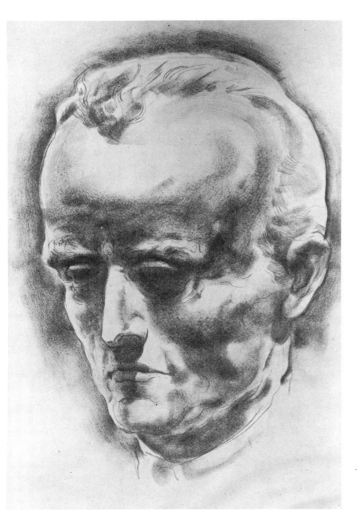

◀

Head Proportions

When you draw the broad-headed skull, you may find that the width of the skull is at least four fifths the length.

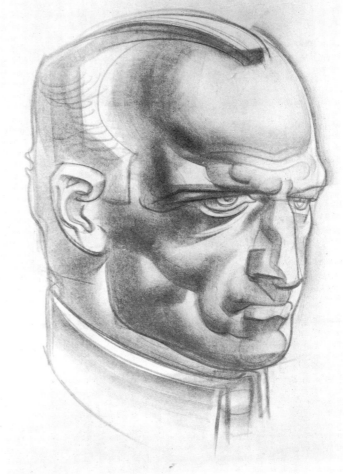

Facial Features

Individuals with *medium to low* foreheads tend to have compact, square, relatively short faces and features.

111

LONG-HEADED (DOLICHOCEPHALIC)

Compared to the broad heads, the long heads seem to have exceedingly narrow skulls. The width of the skull is generally three fourths the length.

Moderately Arched Forehead

The forehead shell, among long heads, varies greatly. In some, the cranium shows a moderate slope.

High, Arched Forehead

The forehead may present a high, arched eminence which curves into the cranial vault.

Facial Features

Persons with a high, vaulting forehead tend to have a generally longer facial structure from crown to chin, with a more extended nose and ears.

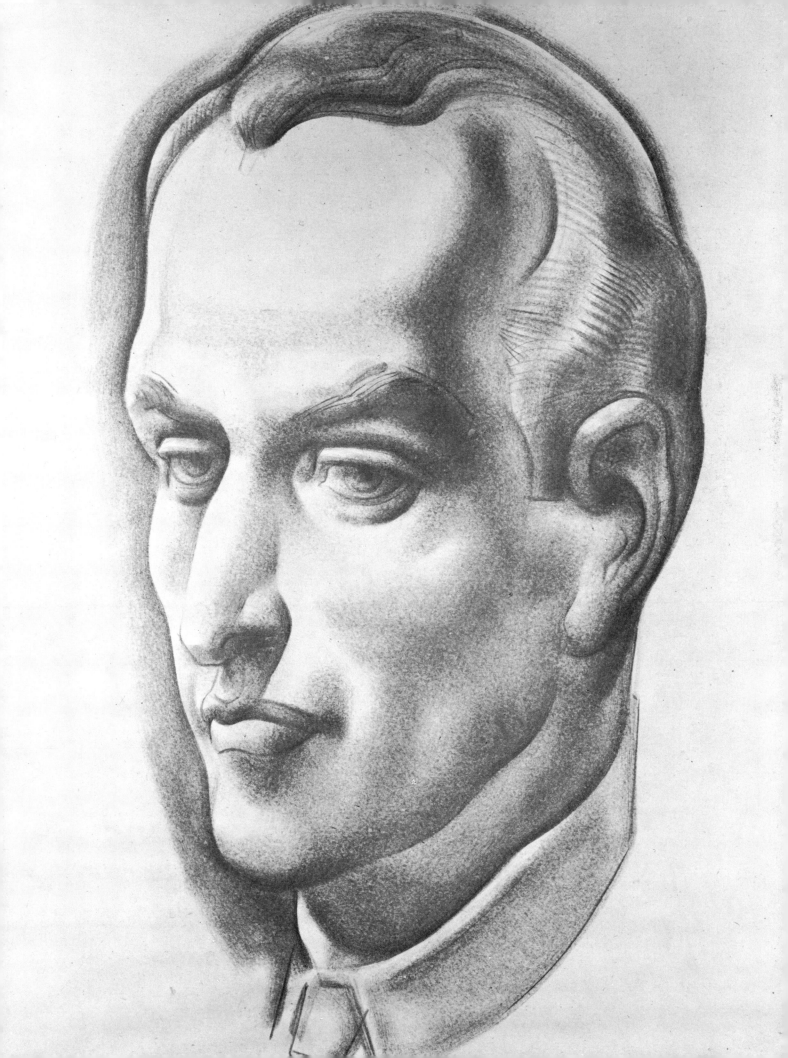

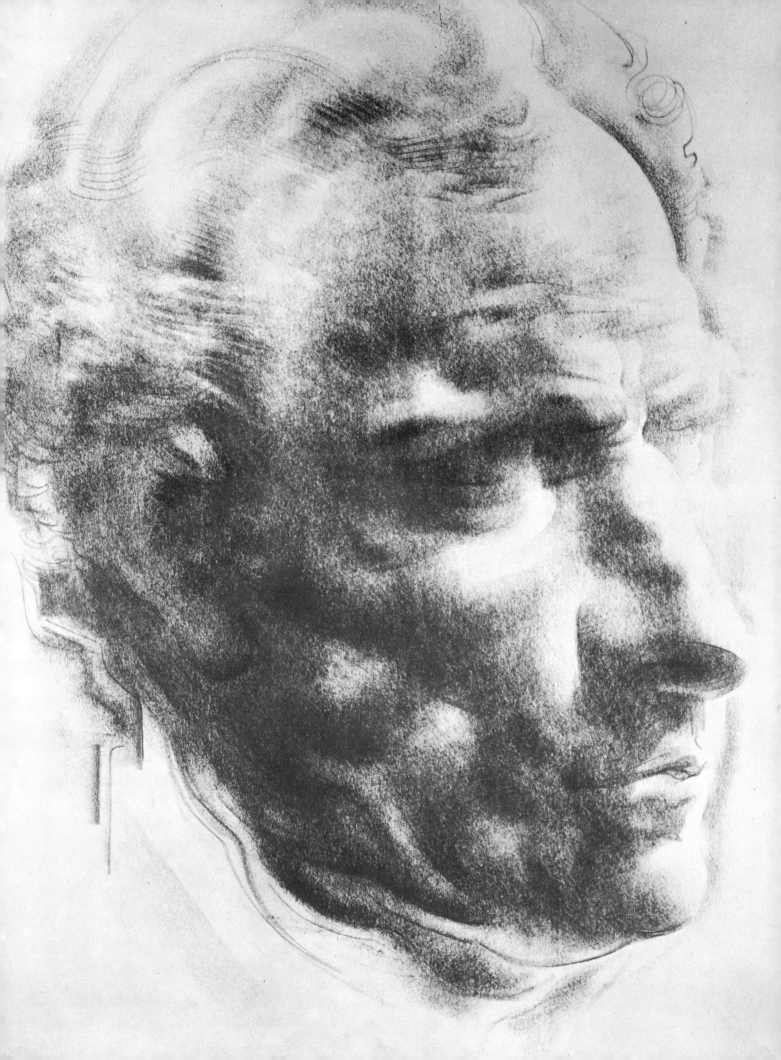

INTERMEDIATE OR MEDIUM-HEADED (MESOCEPHALIC)

Persons in this group generally fall between the two extremes. The forehead is neither highly arched nor markedly shallow.

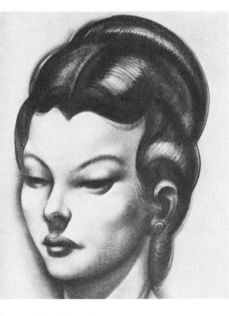

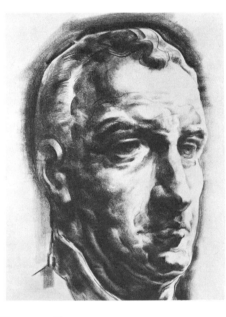

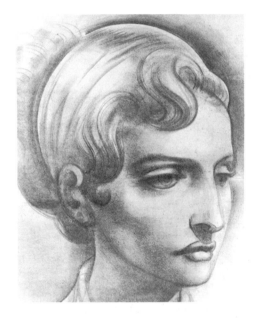

Female Head

Although the female head appears more delicate in detail, it still conforms to the same head type: broad, long, or intermediate. This is an intermediate example. Confirm this by categorizing the head types of the women you observe around you.

Proportions

The proportions of the intermediate group lie between those of the broad and the long heads. Skull *width* is somewhat less than four fifths and larger than three-quarters the *length* of the skull.

Facial Features

Persons with a medium-high forehead tend to have a more ovoid facial structure, with somewhat shorter nose, ears, and chin.

FACIAL SLOPE

There are major differences in the slope of the face, when the face is seen from the side view. This slope reflects the forward thrust of the front teeth (incisors) as compared with the forehead (disregarding the nose, of course). Three characteristic profiles emerge.

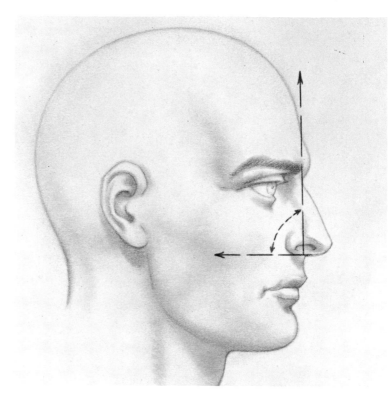

Steep Slope

When the facial angle is steep, the slope is *vertical*. Individuals in this group show the *least* projection of the front teeth (prognathism).

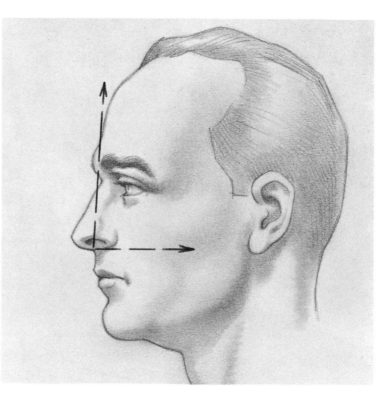

116

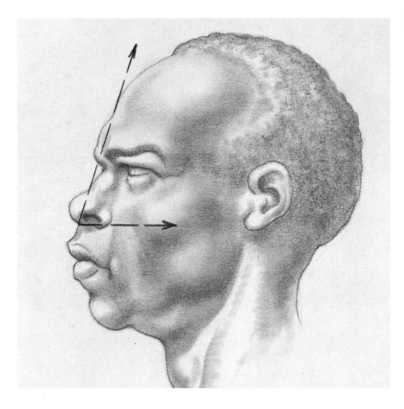

Diagonal Slope

At the other extreme, the profile is *markedly slanted*. There is a profound projection of the dental bulge.

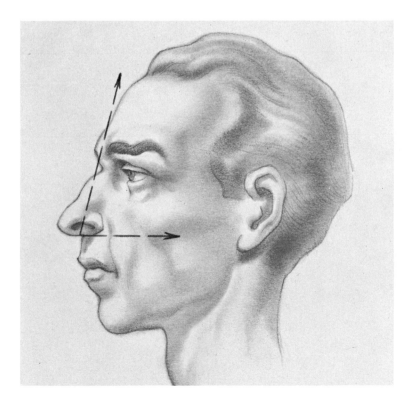

Moderate Slope

Between these two extremes, the middle group shows a moderately upright profile.

EXAMPLES OF HEAD TYPES

No one particular group of persons can be identified by a single head type classification or facial slope. Head form variations run through the individuals of all population groups the world over. In the following drawings, we shall see a sampling of persons, chosen merely for visual interest and physical variety, who reveal the various head form traits in varying relationships.

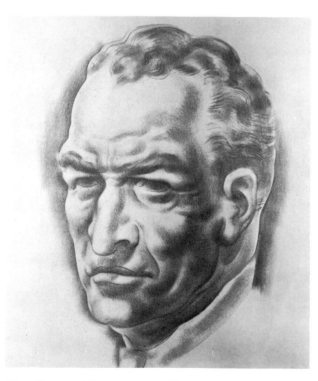

Southern European Man (Italy): Broad Head Type; Steep Facial Slope.

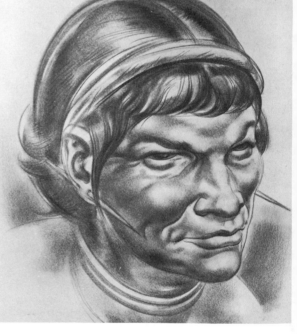

Equador Indian Man (Jivaro): Medium Head Type; Moderate Facial Slope.

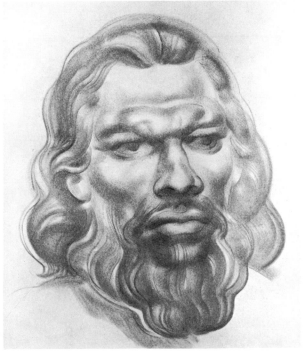

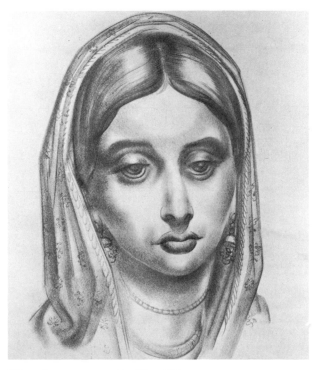

119

Southern India-Ceylon Man:
Medium Head Type;
Diagonal Facial Slope.

Northeastern India Woman
(Bengal): Medium Head
Type; Steep Facial Slope.

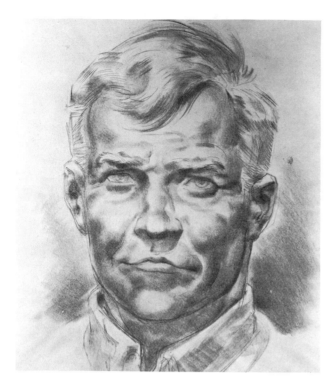

Eastern European Man (Ukraine): Broad Head Type; Steep Facial Slope.

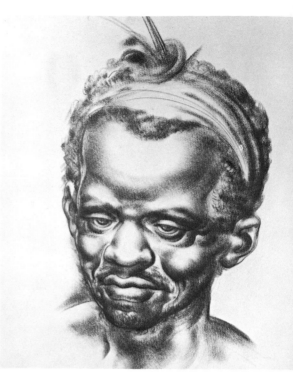

Central African Pygmy (Congo): Broad Head Type; Diagonal Facial Slope.

120

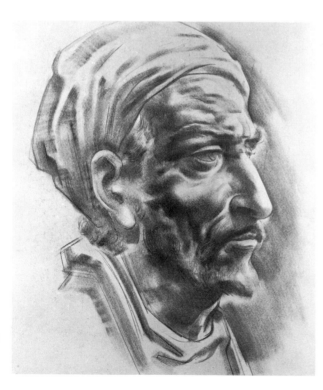

North African Man (Berber, Morocco): Long Head Type; Steep Facial Slope.

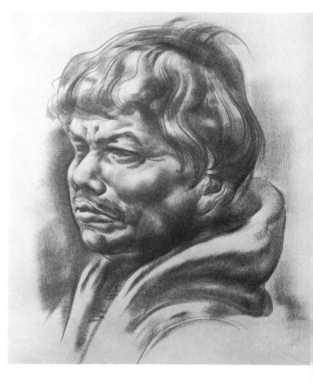

North American Eskimo Man (Arctic Fringe): Medium Head Type; Moderate Facial Slope.

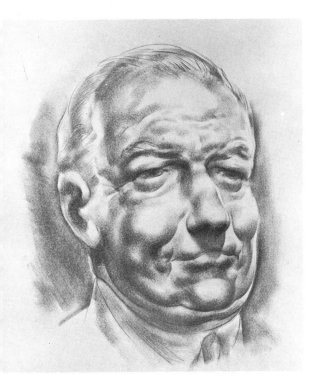

Central European Man
(Austria): Broad Head Type;
Steep Facial Slope.

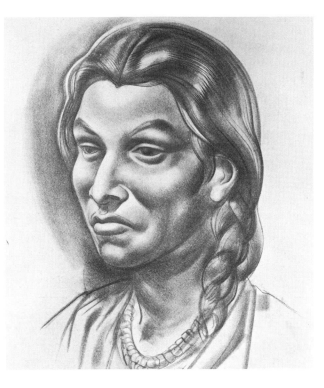

Guatemala Indian Woman:
Medium Head Type;
Moderate Facial Slope.

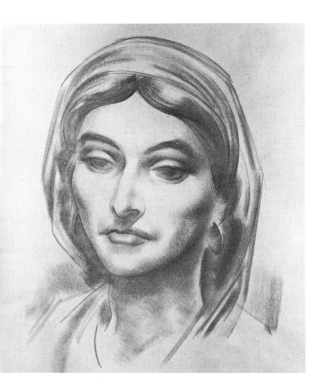

Asia Minor Woman
(Turkey): Medium Head
Type; Moderate Facial Slope.

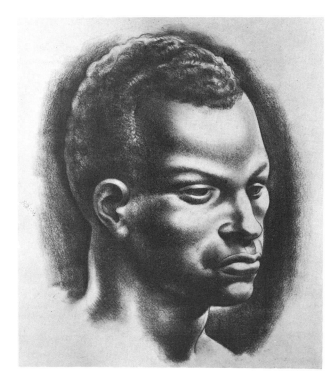

West African Man (Nigeria):
Long Head Type;
Moderate Facial Slope.

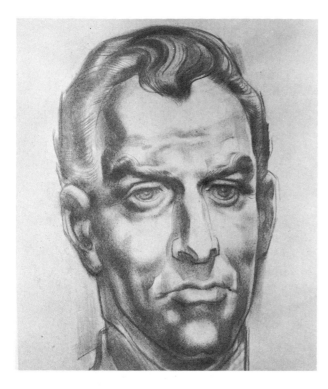

West European Man (Great
Britain): Long Head Type;
Steep Facial Slope.

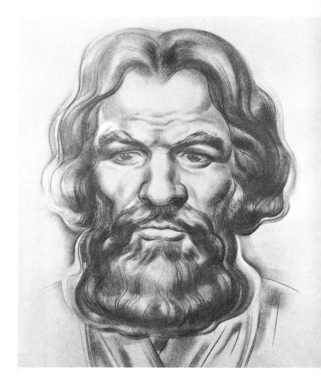

Northern Japanese Man
(Ainu): Broad Head Type;
Steep Facial Slope.

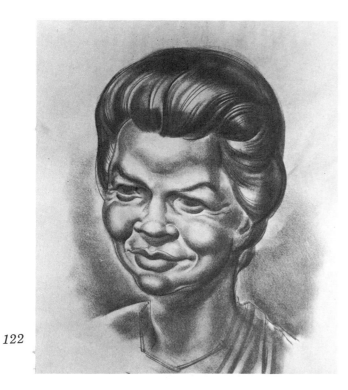

Indonesian Woman (Java):
Broad Head Type;
Moderate Facial Slope.

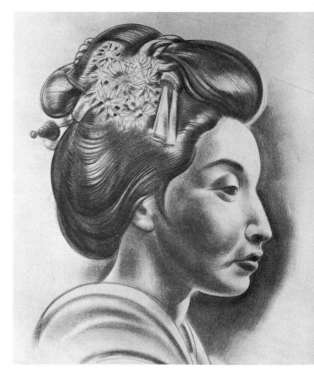

Eastern Asian Woman
(Japan): Medium Head
Type; Moderate Facial Slope.

122

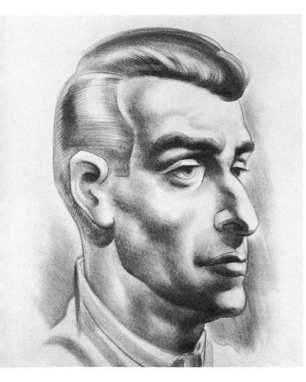

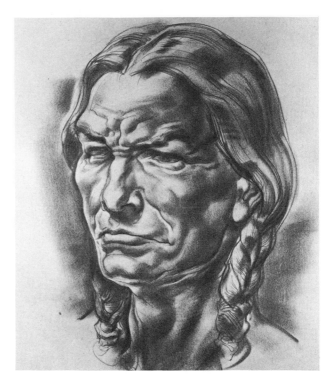

Southwestern European Man
(Spain): Long Head Type;
Steep Facial Slope.

Western United States Indian
Man (Sioux): Broad Head
Type; Moderate Facial Slope.

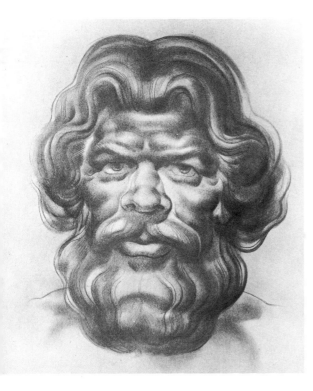

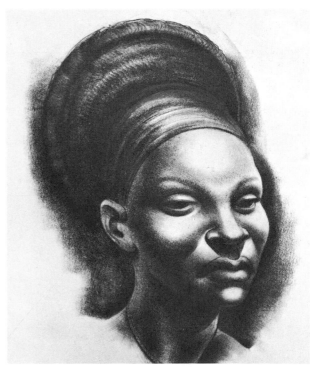

123

Northeastern Australian
Man: Long Head Type;
Moderate Facial Slope.

Central African Woman
(Congo): Long Head Type;
Diagonal Facial Slope.

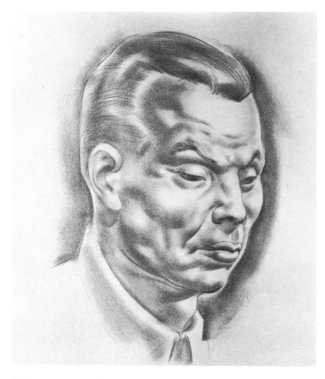

Eastern Asian Man (China):
Medium Head Type;
Moderate Facial Slope.

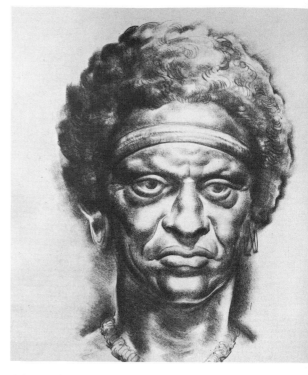

New Guinea Man (Papua):
Broad Head Type;
Moderate Facial Slope.

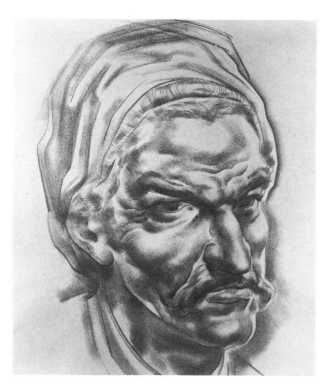

Middle Eastern Man (Iran):
Medium Head Type;
Moderate Facial Slope.

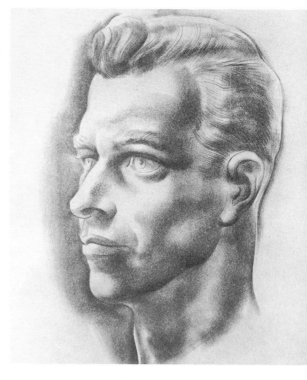

Northern European Man
(Sweden): Long Head Type;
Steep Facial Slope.

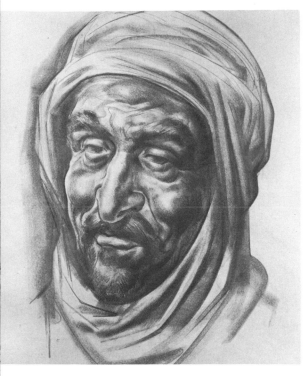

*Near Eastern Man (Saudi
Arabia): Long Head Type;
Steep Facial Slope.*

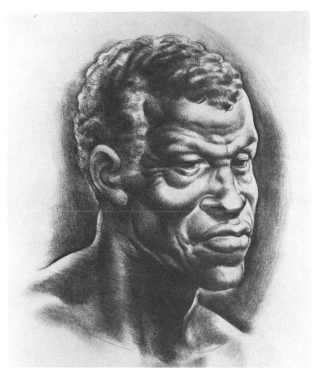

*South African Bushman
(Kalihari Desert): Long
Head Type; Diagonal
Facial Slope.*

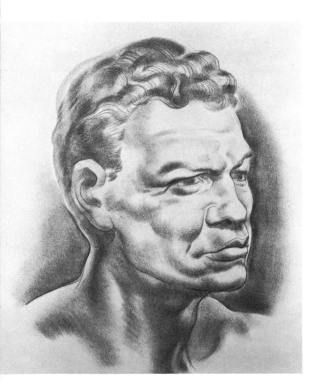

*Polynesian Man (Samoa):
Broad Head Type;
Moderate Facial Slope.*

6.
Gallery
of
Great
Heads

SUMMARY AND DOCUMENTATION OF DRAWING PRINCIPLES

We have come to a point where it is possible to assess the drawing principles presented in the preceding chapters. In the following pages, we shall reproduce a gallery of heads by masters of drawing, painting, and sculpture. With this gallery of great examples, we shall attempt to document our propositions of form and structure, order and proportion, as well as our generalizations about the organization of contours, planes, tonal values and tactile surfaces. We shall seek to demonstrate empirically that the material in this book is formed from observations which can be verified in art works across the centuries, from early Greek times to the present day.

In every work of art, a synthesis exists between the projection of an *idea* and the shaping of a *form*. When an idea is perceived mentally as an image, the visualizing process is called imagination. The act of making the image visible in some material (clay, paint, carbon, graphite, etc.) is called art. In the shaped material, we see the embodiment of the imagined idea as a *form*. The form—a created object—is a *work of art*.

Now, while all of us may be able to imagine or perceive images, not everyone is capable of shaping forms. The perception of images—the process we call imagination—is derived from the experience of our senses and their capacity to apprehend what happens in nature. But the process of *making images into forms* depends on a special system of knowledge. This process demands an understanding of useful, workable materials; trained motor and technical skills; and, more decisively, a comprehension of forms, their ordered relations and associated meanings, all of which we sometimes call the language of art. Only those who work to master this knowledge, who learn the language of forms, may conceivably produce a work of art.

Knowledge of form, therefore, is essential to every work of art. At this stage of our work, we will attempt to show that art must start from a concise body of form discipline, a grammar of forms, if you will. In the following pages, we shall recapitulate these factors in the works of masters whose outlook and interest spring from a common fund of information. In exploring this gallery of great heads, we shall search out certain salient features which, we hope, will illuminate and reinforce the propositions advanced in this book.

Lest there be any misapprehension as to the intent of this book, we must assert that it deals only with the *precursory* measures upon which a work of art is based. Our purpose has been to lay the groundwork of form comprehension. But once this foundation is established, and the reader has reached a stage of freedom wherein this basic knowledge is taken for granted, the reader's performance moves into the domain of personal expression. From here, the commonplace similarity of form is reconstructed by individual temperament into the sense values of the shaped image, the aesthetic work of art.

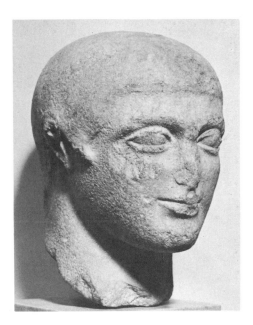

HEAD OF A YOUTH
(BROKEN FROM A STATUE)
Marble Sculpture

Greek, early Fifth Century B.C.
(ca. 490 B.C.)

The Metropolitan Museum of Art, Rogers Fund, 1919.

In this archaic Greek head, the basic masses are established with rigorous simplicity and clarity. Despite the loss of details in the chipped nose, lips, lids and ear, the structure of the ovoid cranial mass and the tapered facial mass still forcefully assert the decisive character of the head.

It is wise to remember, as the early Greek sculptor shows us, that the essence of drawing lies in developing the great masses first. Whatever forms may be added later, these primary structures *alone* are capable of producing the fundamental form of the head.

127

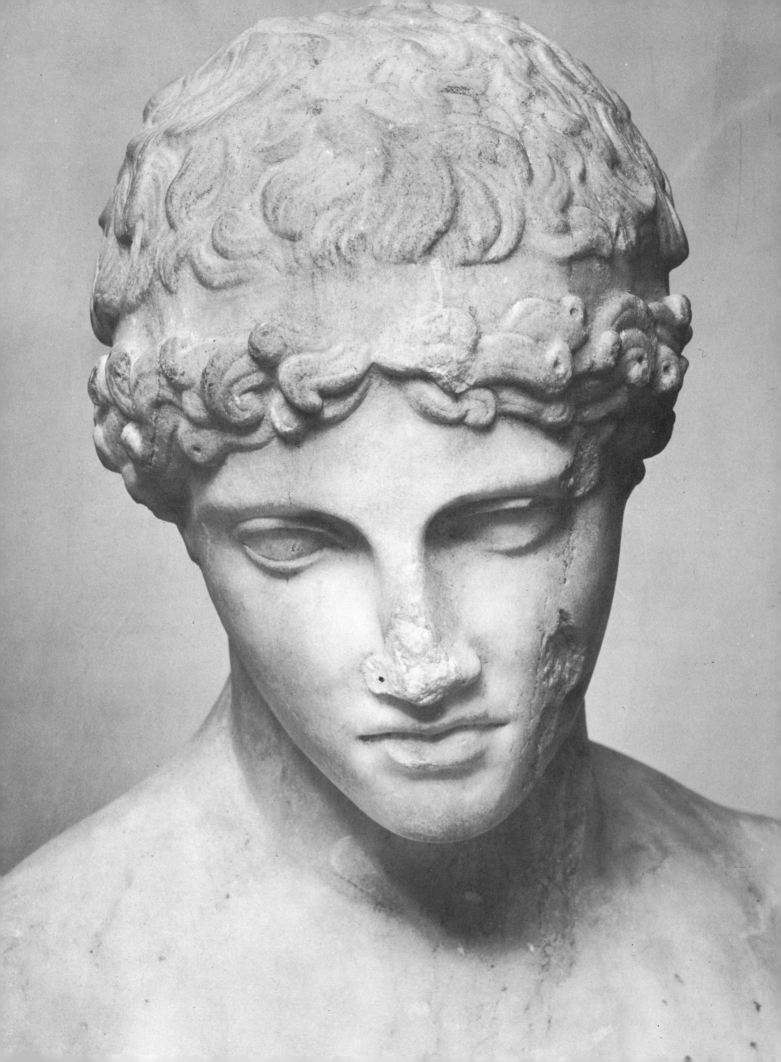

HEAD OF A YOUTH
(DETAIL OF A STATUE)
Marble Sculpture

Greek, Fifth Century B.C.
(450–425 B.C.)

*The Metropolitan Museum
of Art, Fletcher Fund, 1926.*

In this downshot view of a Greek youth, the cranial form fully supports the external mass of hair and curls.

The view from above the head presents a clear distinction between the two different curves of the eyelids. Seen this way, the upper-lid curve is inhibited and quite flat, in contrast to the rounder curve of the lower-lid line.

Here we see how the eyes are set in the sockets just below the overhanging brow bone. They are spaced the length of an eye apart. In another sense, this measure between the eyes can be taken from the extreme width of the nostril wings.

HEAD OF AN ATHLETE
Marble Sculpture

Roman copy of a Greek Sculpture, 3rd Quarter Fourth Century B.C.

*The Metropolitan Museum
of Art, Rogers Fund, 1911.*

This classic Greek head gives us three views of the secondary forms and features:

Side View: In the side view, see how the eyelids are located on an oblique line from the advanced upper lid to the recessive lower lid. Further, note how this oblique line, if continued, tends to meet the corner of the jaw. From this point, a line carried horizontally toward the profile will carry into the mouth slit and lower lip.

Front View: Check the width of the mouth in this front view and observe how the mouth corners terminate on lines carried down from the midpoints of both eyes. This relationship can be seen in all three views of the head on this page.

Three-Quarter View: Finally, judge the correct placement of the near eye in the three-quarter view. The inner corner of the eye will be seen to start on a point directly above the edge of the nostril wing.

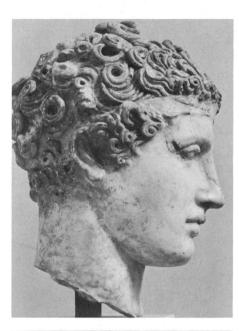

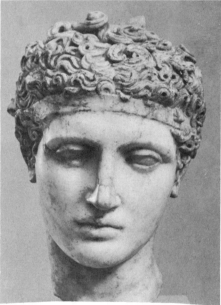

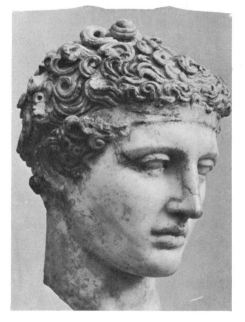

HEAD OF AN APOSTLE
*Black and white chalk
on white paper*

Anthony van Dyck
(1559–1641)

*The Metropolitan Museum
of Art, Gift of
Mr. and Mrs. Janos Scholtz,
1952.*

In an upshot foreshortening of the head seen from below, van Dyck shows how the eyelid curves are reversed. Set against the raised plane of the head and the arched swing of the brow, the upper lids take on a marked crescent-shaped curve while the lower lids are virtually straight.

The foreshortened up view is further emphasized in the elliptic shapes of the pupil discs; the upthrust triangular nose base; the low-set cheek bones on the curved facial plane; and the thrust of the chin mound through the beard, implying the recessed understructure of the jaw.

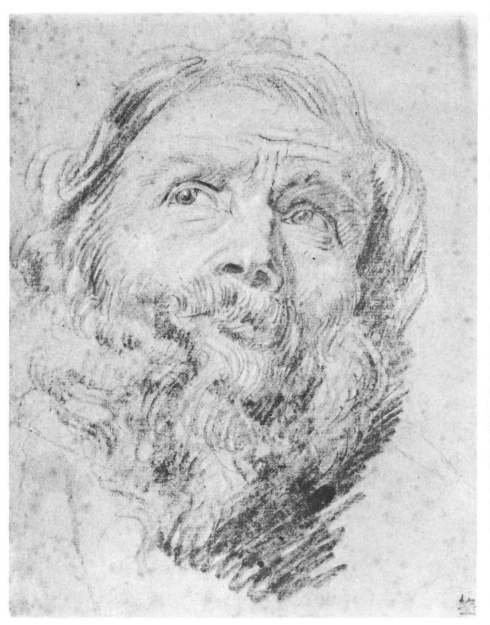

PORTRAIT OF AN OLD MAN
Marble Sculpture

Roman, First Century B.C.
*The Metropolitan Museum
of Art, Rogers Fund, 1921.*

This lean, long-jawed individual presents an excellent example of the frontal wrinkle pattern which emanates from the narrow nose root at the bridge and the nostril wings at the base. The wrinkle pattern can be traced in the vertical compressions that start from the eyebrows and engage the horizontal forehead furrows. Then the pattern emerges from the nose wings and courses downward, holding to the perimeters of the mouth bulge and chin mound.

This trenchant portrait, with its gaunt face and narrow cranial box, gives us an explicit specimen of the long-headed or dolichocephalic skull form.

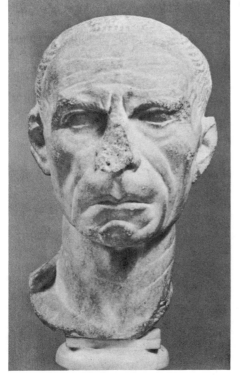

HEAD OF A MAN
Marble Sculpture

Roman, First Century B.C.
(Late Republican Period)
*The Metropolitan Museum
of Art, Rogers Fund, 1917.*

Despite the missing fragment of the nose, this head clearly shows the emerging wrinkle patterns of the nose. Note how the oblique pattern, starting from the inner corner of the eye and moving into the midface, is distinguished from the frontal pattern, which turns around the nostril wing and holds to the lower cheek contour. The wide-set lateral wrinkle group, beginning at the outer eye corner, radiates upward to the forehead and downward to the extreme edge of the jaw and neck.

Of the three generic classes of head type, this version appears to be a remarkable example of the broad-headed or brachycephalic type.

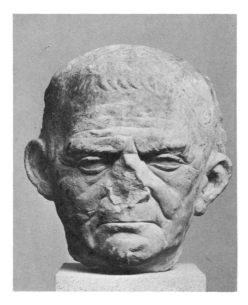

**PORTRAIT HEAD OF THE
EMPEROR CARACALLA**
Marble Sculpture

Roman, Third Century A.D.
*The Metropolitan Museum
of Art, Samuel D. Lee Fund,
1940.*

The upward direction of the oblique wrinkle pattern is presented with incisive clarity in this portrait. The pattern thrusts from across the nose bridge and projects angularly over the brow to merge with the furrows of the mid-forehead. This vigorous accent is no overstatement, for it injects a revealing psychological tension in the imperious characterization of the emperor's personality.

In an over-all classification, this head can be assigned to the intermediate or mesocephalic skull type, wherein the general configuration of the cranium is neither broad nor narrow.

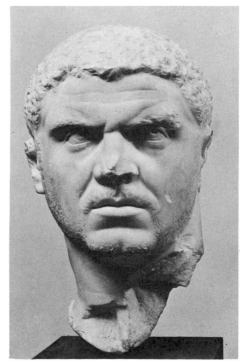

131

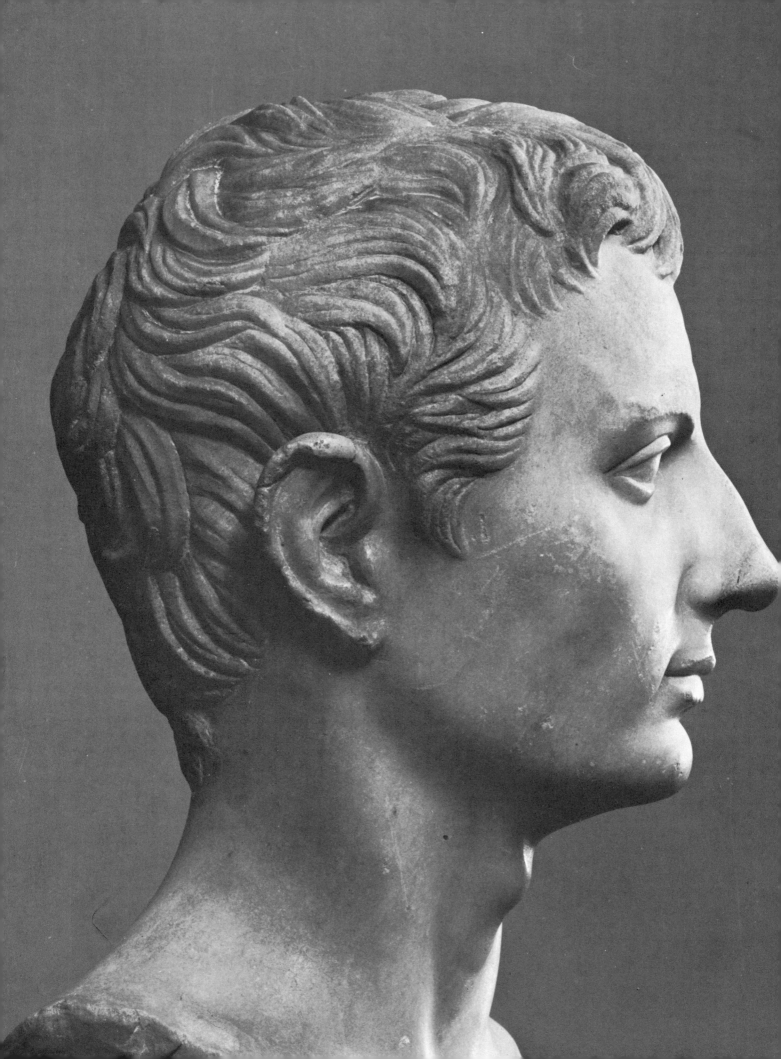

PORTRAIT OF A YOUNG MAN
(PERHAPS AUGUSTUS)
Marble Sculpture

Roman, Augustan Period
(ca. 30 B.C.)

*The Metropolitan Museum
of Art, Rogers Fund, 1919.*

This profile view confirms the means by which the front neckline is established under the jaw. A line starting from the tip of the nose, touching the lips, and continuing downward strikes the forward projection of the laryngeal box or Adam's apple.

In another note on form placement, see how the ear is set at the side of the jaw line. The length of the ear equals the distance between the eyebrow and nose base.

PORTRAIT OF AN UNKNOWN
MAN (DETAIL)
Pencil on paper

Jean-Auguste Dominique
Ingres (1780–1867)

*The Metropolitan Museum
of Art, Rogers Fund, 1919.*

A penetrating simplicity emerges in a drawing developed from a single source of light. In this manner, Ingres shows the massed side plane of the head, with the shadow edging the depressed temple wall and the emerging cheek mound.

Again, the deep hollow of the eye socket is joined to the nose forms which spread to form the triangular nose wedge. The mouth bulge is more subtly expressed; since the subject is an older person, the cheek folds and mouth line are specially emphasized to express the nuances of incipient shrinkage wrinkles. The upper head mass is drawn in a linear shorthand; the stroked modeling of the hair explains the cranial vault underneath.

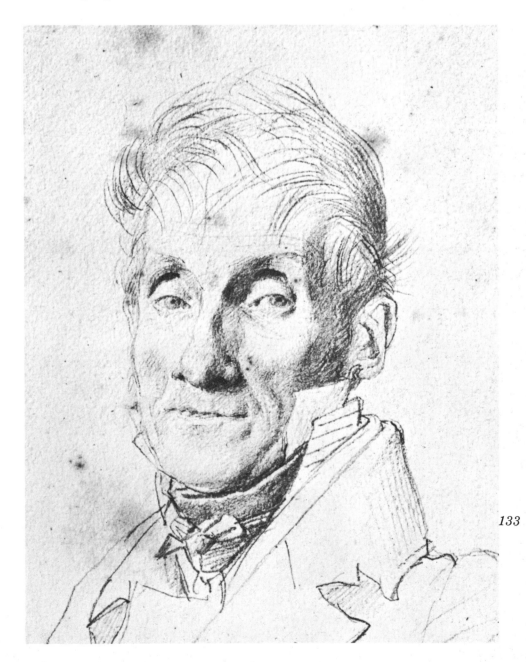

133

PORTRAIT OF AN OLD WOMAN (DETAIL)
Oil on canvas
Frank Duveneck (1848–1919)
The Metropolitan Museum of Art, Morris K. Jesup Fund, 1923.

The look of old age: how ably the artist has juxtaposed the hard-edged bony projections beneath the corrugated fleshy surfaces. Most notably, he defines the furrowed brow and sockets with the eyes sunk deeply within. Especially praiseworthy is the handling of the tight lips holding to the bony forms. The lips are checked with cross-grain rifts, while on the perimeter two curtains of sagging cheek folds descend, laced with surface irregularities. Although a wealth of detail is recorded, the artist has not overstepped the sensitivity with which these subtle form nuances are disclosed.

LADY IN A RIDING HABIT— L'AMAZONE (DETAIL)
Oil on canvas
Gustave Courbet (1819–1877)
The Metropolitan Museum of Art, Bequest of Mrs. H. O. Havemeyer, 1929.

While Courbet draws attention to the compelling near eye with its dark accent, the artist's mastery of draughtsmanship is revealed in the muted handling of the mouth, the sensitive treatment of the lip curves with their subtle range of form tones. How artfully he permits the slight sidewise tilt of the head to expose the nose in a double relief: the nose contour is keyed against a darkened facial plane; the structured nose base is silhouetted against a lightened cheek plane. From here, the lip channel, descending darkly, engages the delicate mouth forms and the barely perceptible chin mound. Then, from below, the ribbon frames the jaw and joins the dark mass of hat and hair, thrusting the head into an impressive three-dimensional relief.

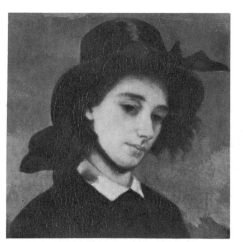

LADY WITH A PINK (DETAIL)
Oil on canvas
Rembrandt van Rijn (1606-1669)
The Metropolitan Museum of Art, Bequest of Benjamin Altman, 1913.

Rembrandt's consummate skill as a draughtsman is seemingly belied in the casual, almost careless, use of the brush with which forms and contours are coarsely laid in. But underneath these surface aspects the positions of the decorative headband and the fillet of pearls reveal two counter-curves of the cranial vault; the first curve moves *over*, the second *around* the upper crown. At the same time, the pearl on the forehead subtly engages the curving center line of the frontal plane of the head.

The facial planes recede in tone from top to bottom (compare the forehead and chin base) and from left to right (check the value changes on each of the pearls). The most artful treatment of structural relationships can be seen in the handling of the eyes. The modeling indicates the degree of turn and the progression of value from the near to the far eye. But far more effective is the finesse of accent between both. The near eye—with its heightened color contrast, translucent pupil, and keenly inserted highlight—commands the central head bulge and becomes the focal point of the entire head.

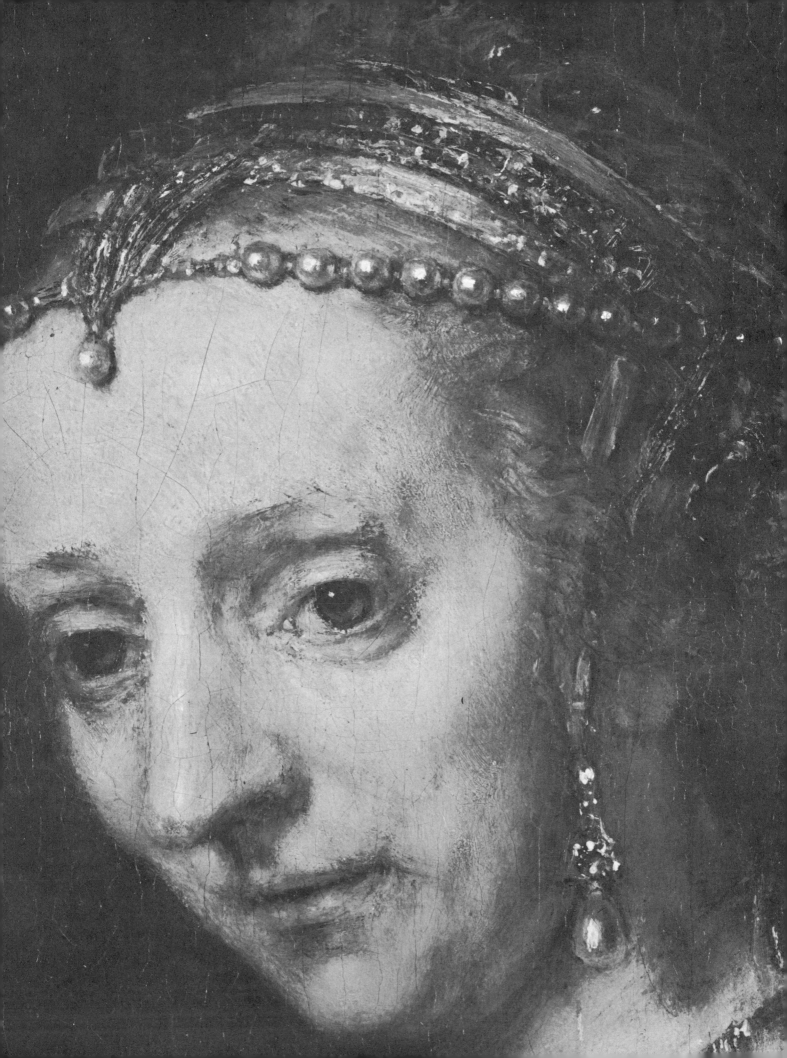

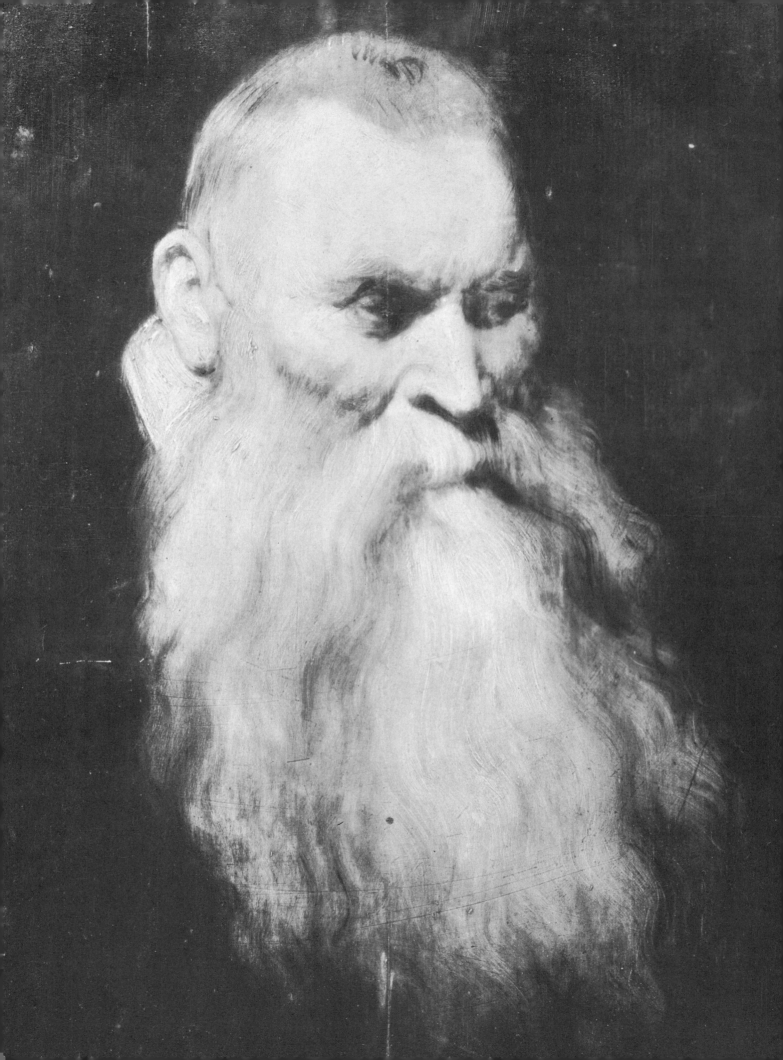

PORTRAIT OF AN OLD MAN
Oil on wood

Peter Paul Rubens
(1577-1640)

The Metropolitan Museum of Art, Egleston Fund, 1922.

The condition of age is essentially a result of the withering and shrinking of the bony and fleshy tissues. Under extreme illumination, Rubens establishes with subtlety and economy the data of old age. In the silvery sheen of fine hair on the balding crown and in the patriarchal beard, we find the dark accents of the understructures: the cranial bulge, the deep-set sockets, the elevated cheek mounds, the articulated nose projection, the contracted mouth corners. Then he adds the finer nuances of fleshy rifts on the brow, the nose bridge, the eye corner, and the cheek cover. His final tactics are the acute insertion of the profuse eyebrow hair, the sagging eye fold, the pendulous ear lobe, and most engaging, the high, white collar which thrusts the head downward into the confirmed body stoop of old age.

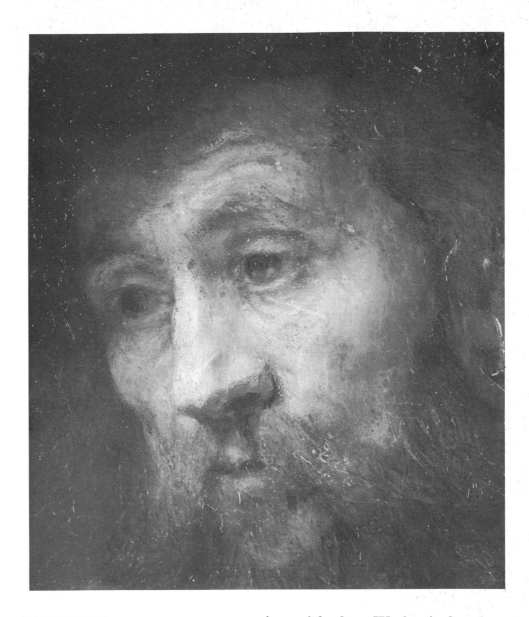

ARISTOTLE CONTEMPLATING THE BUST OF HOMER (DETAIL)
Oil on canvas

Rembrandt van Rijn
(1606-1669)

The Metropolitan Museum of Art, 1961.

Unless a profound knowledge of form can be called upon, boldness of execution cannot show anything but the mere exercise of the brush. To be authentic and significant, stroke and form must be integrated. In this head, Rembrandt shows restless brushwork which is built up like the technique of a sculptor modeling with clay. We begin by observing the triangular blocking of the nose wedge, the forcing of the upper nose plane, the pushing down of the side plane, the cutting of the nose base and gouging of the nostril. Then we slowly drift from the unmannerly paint stroke into the flesh, bone, and vibrant presence of the living man. The eyes peer from the deep sockets in translucent shadows; the slack half-hidden mouth, barely open, begins to phrase wordless sounds. This is when paint, controlled by the intelligence of form, passes into the realm of art.

YOUNG WOMAN WITH A WATER JUG (DETAIL)
Oil on canvas

Johannes Vermeer
(1632–1675)

The Metropolitan Museum of Art, Gift of Henry G. Marquand, 1889.

The light source, directed from the left, produces a clear expression of planes in high and low relief; the effect is one of structural simplicity and spatial coherence of all the parts. This even-tempered precision is almost prosaic, except when we note how Vermeer has used the bonnet to play out the balance of the head mass. The thin material becomes a veil through which the opaque volume of the cranium is revealed; the subtle penetration of light permits the rear skull and neck to be shown. Against this, a reverse shift illuminates the translucent plane of the right face and chest. Finally he releases a semi-transparent glow through the left bonnet wing, against which the contour of the facial mass is securely enclosed.

HEAD OF A YOUNG BOY
Red chalk on paper

Jean-Baptiste Greuze
(1725–1805)

The Metropolitan Museum of Art, Rogers Fund, 1949.

Command of a youthful head in this view can come only from a profound awareness of the total head mass. The overall structural unity is given cohesion by the spherical build-up of lines, which are worked in curved array from the left eye region and then course outward to the rotund perimeter of the head. The features are kept consistent with the conception of the upshot view. Strong curved accents hold the circumferential upper lid lines; lesser curves engage the nose base, mouth, and lips; then the spheroid curves reverse to take up the under arcs of cheeks, chin, and neck.

DON BERNARDO DE IRIARTE
Oil on canvas

Francisco de Goya
(1746–1828)

The Metropolitan Museum of Art, Bequest of Mary Stillman Harkness, 1950.

Underscoring accents in the recessive areas of forms is one means by which Goya extracts the qualities of his sitter's identity. For example, the dark touches under the nose tip and the nostril cavity tend to define a lean, taut, angular slope. Low tones at the lip line and mouth corners create a retention of the upper lip and protrusion of the lower lip. Incised values at the outer eye edges and nose bridge induce a swelling convexity in the eyes. And the inflected contour of the jaw base tends to send the chin mound out and open the lower lip. Goya's understanding of form is so precise that it is with his light passages that he reaches the intensity of characterization. See how the light strokes bulge the eye, lift the nose, raise the nostril, assert the lips, swell the cheeks, project the chin.

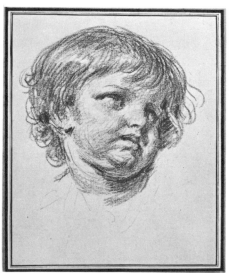

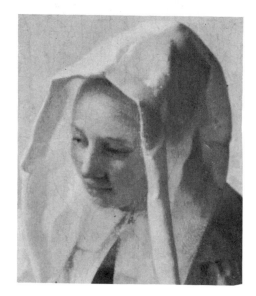

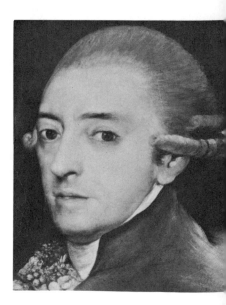

HEAD OF THE VIRGIN
Black and red chalk on paper

Leonardo da Vinci
(1452–1519)

The Metropolitan Museum of Art, Dick Fund, 1951.

Leonardo conceives the head as a great sphere on which he introduces the secondary forms and features. He initiates his approach with a central light source directed from above the head. Then, modeling the globoid mass, he develops curvature with a continuous gradation of values toward the undersurface of the right contour. Selectively, he relieves the major features with heavier pressures and lightly searches out the minor forms with softer touches. He skillfully manipulates the hair as a background to his forms, darkening the mass to show the illuminated brow and cheek, lightening the tones to emphasize the intensified mouth and chin.

HEAD OF A WOMAN
Black crayon on paper

Ludovico Carracci
(1551–1619)

The Metropolitan Museum of Art, Rogers Fund, 1950.

In contrast with Leonardo, Carracci takes a low viewing position and exploits the over-curved directional relationship of the major and minor masses. Holding to this device, Carracci is able to expose all the under planes of his head forms: the brow ridge and eye socket; the nose base; the lip recesses; the chin mound and undercut jaw surface; the cheek plane and neck column. This done, Carracci simply darkens each of the undersurfaces, including the background, and fuses the whole into a homogeneous mass of structured forms.

HEAD OF A MAN
Red and black chalk

François le Moyne
(1688–1737)

The Metropolitan Museum of Art, Rogers Fund, 1910.

The head, from a high view above the crown, shows how forms relate to the great circumferential brow curve. The cranial box, with its helmet-like vault, is well presented, as is the relationship of nose base, cheek bone, ear lobe, and skull base on the low curve under the brow arc. Especially noteworthy is the handling of the mouth and eye curves on the foreshortened frontal plane of the face. The finesse of the inside socket curve and the tight, elliptical pupil discs lend veracity to this downshot head.

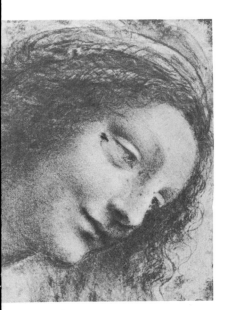

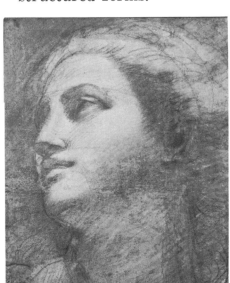

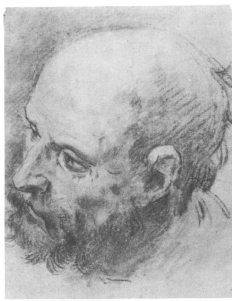

MAN IN PRAYER
Tempera and oil on wood

Robert Campin
(active 1418–1444)

The Metropolitan Museum of Art, Bequest of Mary Stillman Harkness, 1950.

With an extraordinary economy of means, Campin lets us see the facial qualities which characterize aging. Relying mostly on the rigid substratum of the skull overlaid with a flaccid flesh cover, he skillfully describes the simple forehead furrows; the emerging cheek mounds; the flat mantle of flesh drooping in undulant folds below the jaw; the constrained mouth and chin; the elongated ear; the sagging eye and mouth wrinkles, with the spare bridge and crow's-feet rifts; and finally the marginal tufts of fine-spun hair on the cranial vault.

140

PORTRAIT OF A MAN IN A TURBAN
Tempera and oil on wood

Rogier van der Weyden
(ca. 1400–1464)

The Metropolitan Museum of Art, The Jules S. Bache Collection, 1949.

According to van der Weyden, painting is conceived as a coloring of forms in relief, with drawing as a primary base. This linear tendency enables him to edge his contours with darks in order to elevate his forms in relief. If the drawing is consistent and precise, form control is elegantly sustained. However, if an error occurs, the effect is noticeable. In this respect, we note that the right mouth corner seems overextended, just beyond the midpoint of the eye above. At first glance, this seems to put the mouth out of drawing. Yet, if we look at the tone of the dental bulge under the lips, we see the true structural position. The retracted mouth corner is *not* a distortion; it is a wry expression the painter has observed and recorded. See how the cheek curve responds to the mouth tension on the right, while the left side remains relaxed and passive.

PORTRAIT OF A YOUNG MAN ▶
Tempera and oil on wood

Giovanni Bellini
(1430?–1516)

The Metropolitan Museum of Art, The Jules S. Bache Collection, 1949.

This notable example of the head as living sculpture is firmly shaped with light–dark planes. The hair is built like a helmet which shows tonal and linear turns of form. The structuring of the eyes, lids, and pupils is so secure that even the eyeball is given its spheroid form by the light. Note the suave detailing of the nose: the curving tip, the nostril wings, the side plane joining the girdle of the socket. The mouth and lips—the projecting tubercle, the incurving corners—give full knowledge of every form. The strong jut of the chin and jaw in front of the recessive plane of the face completes a memorable impression of unity.

THE MUSICIANS
Oil on canvas

Michelangelo Amerighi
Caravaggio (1560/5–1609)

The Metropolitan Museum of Art, Rogers Fund, 1952

It is interesting to note the age levels of the four youths Caravaggio shows us. How old are they, and on what basis shall we decide? On the extreme left is the youngest. Observe the smooth curve of the cheek and jaw line. The turn of the cheek is scarcely affected by any show of the cheek bone under the round fleshy surface. The chin is simply a continuation of the ovoid facial contour, and the facial forms are generally small, soft, and immature. While the front neck line shows a slight mound of the voice box, the neck column is slender and the body mass has little bulk. This youth, we infer, is a teen-ager, hardly more than fourteen years old. The second youth from the left is older. Not only does the jaw corner appear, but the firmer jaw line, cleft chin, flatter cheek contour, and somewhat inflected nose tend to prove this. Observe the more mature body frame and the thicker neck column. This lad is about seventeen or eighteen years old. The youth in the background (second from right) appears to be the oldest. Note the more decisive facial angularity: the deeper nose bridge, emerging nasal bone, distinct under-eye curve, more assertive cheek tautness. He is between nineteen and twenty years of age. What of the youth with his back to us? The firm planes of the nose tip suggest a level of maturity, unlike the round nose of the first lad. But the subtle rise of the cheekbone and brow against the uninflected jaw angle shows him to be somewhere between the oldest and the youngest. Hence, he is about sixteen years old.

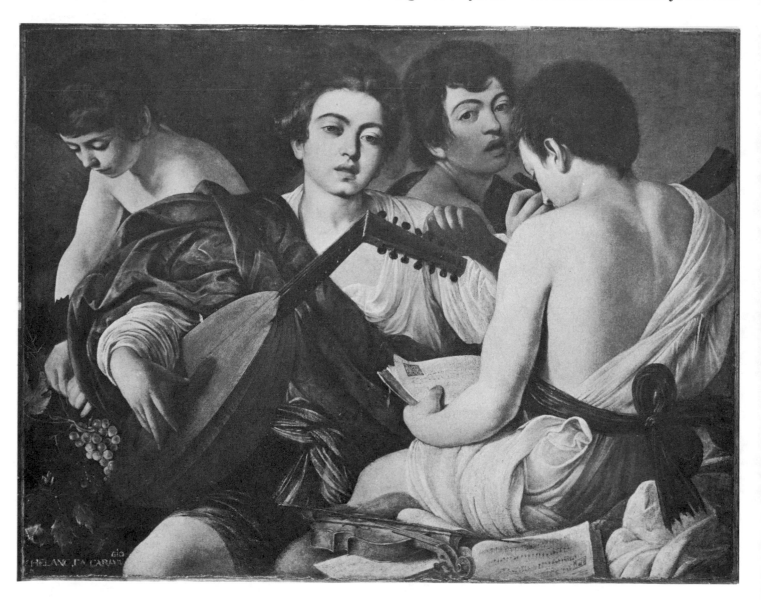

STUDY FOR THE LIBYAN SIBYL
Red chalk

Michelangelo Buonarroti
(1475-1564)

The Metropolitan Museum of Art, Purchase, 1924, Joseph Pulitzer Bequest.

In this overview of the head, Michelangelo turns the position almost into a profile while tipping the mass over to its side. This subtle attitude is asserted with a number of small but decisive clues. Just above the nose bridge, he shows the far brow bulge. On the eye, the arc of the upper lid dominates the lower and tends to force the orb deep into the socket. The swing of the upper lip curve goes beyond the center groove and rotates the mouth into view. Heavy accents under the forms on the right produce a box-like effect which further suggests the oblique tilt. The spiraling neck wrinkles show the twist of the head in our direction. This twist is confirmed by the simultaneous lift of the shoulder in reverse, which confirms the wrench-tilt position.

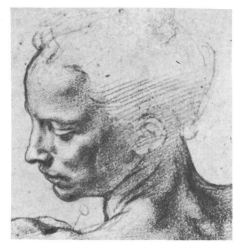

PORTRAIT OF
WILLIBALD PIRKHEIMER
Engraving

Albrecht Dürer (1471–1528)

The Metropolitan Museum of Art, Fletcher Fund, 1919.

The modeling process, as Dürer performs it, is almost like carving. A multiple series of fine-spaced lines is stroked in to extract the topographical array of forms and textures. He explores the undulant course of hair, the thick-set brow, the heavy eyes, the broad nose, the full-hewn lips, the ample chin, and the pendulous jowl. Form after form, he explores the relative sequence of planes in depth. But there is no passage so perceptive as the incisive probing of the mouth, chin, and jaw. The lips protrude over the maxillary bulge, and this joins the far-left contour of the higher cheek. The under-mouth recess is inflected against the thrust of the jutting chin, which brings the left outline into play toward the inner face. Below, the heavy jaw flesh swings from left to right under the dark curls. Then the rear neck fold reverses and rings the throat with a fatty collar to engage and complete the facial line.

PORTRAIT OF MARGARET WYATT, LADY LEE (DETAIL)
Tempera and oil on wood

Hans Holbein the Younger
(1497/98–1543)

The Metropolitan Museum of Art, Bequest of Benjamin Altman, 1913.

The development of depth in this spare and meticulous head is accomplished by overlapping form over form in sequence, and playing out contrasting areas of tone. To this end, Holbein takes advantage of a three-quarter view and penetrates the facial contour with the incisive nose, the taut chin, the fine extension of the eyelash. Great curving arcs on the headpiece produce a series of turns like a tunnel through which the head emerges; then the device is carried to the neckband to let the chin and jaw through, and to the necklace and collar to ring the neck and shoulders. His modeling of forms is only incidental to his linear effect, for his use of tone is introduced to support and enhance an overlapping edge. See how the tone on the chin base and behind the nose line qualify these edges.

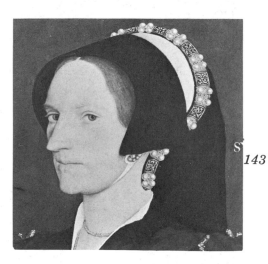

PORTRAIT OF MADAME GRANT, LATER PRINCESSE DE TALLEYRAND-PERIGORD (DETAIL)
Oil on canvas

Louise Elisabeth Vigée-Le Brun (1755-1842)

The Metropolitan Museum of Art, Bequest of Edward S. Harkness, 1940.

A lyrical treatment of a head requires grace of attitude, delicacy of form, sensuousness of surface, and suavity of brush work. The lightness of the elevated head is reinforced in the rise of the upper eye and brow curves, the lift of the lip forms and mouth corners, the upward tilt of the nose, the elongation of the neck column. The sinuous brush rhythms of hair, undulant curls, and swaying ribbons induce a feeling of lightness. All this may tend to convey an excess of mannered and superficial charm. But the attempt, however inane, is always secure in the artist's fundamental knowledge of form.

JONKER RAMP AND HIS SWEETHEART (DETAIL)
Oil on canvas

Frans Hals (after 1580–1666)

The Metropolitan Museum of Art, Bequest of Benjamin Altman, 1913.

A mobile expression, as in this capricious show of laughter and merriment, depends on a rigorous grasp of structure to effect an agreeable result. Otherwise, an inexact knowledge of facial structure may produce an eccentric or perverse grimace. In these up-turned and down-turned heads, the wry facial tensions around the mouths hold clearly to the maxillary dentures and the jaw formations. And while Hals' uninhibited brush communicates a spontaneous effect of gaiety, we still find in the squint of the eyes, the stretch of the lips, the lift of the cheeks, the drop of the jaw, the solid skull structures underneath. This adherence to form produces a Falstaffian humor, while an ignorance of form reveals the floundering distortions of the amateur.

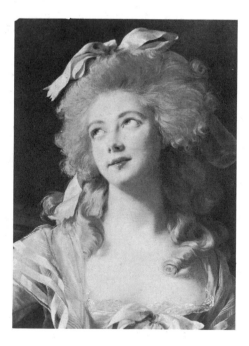

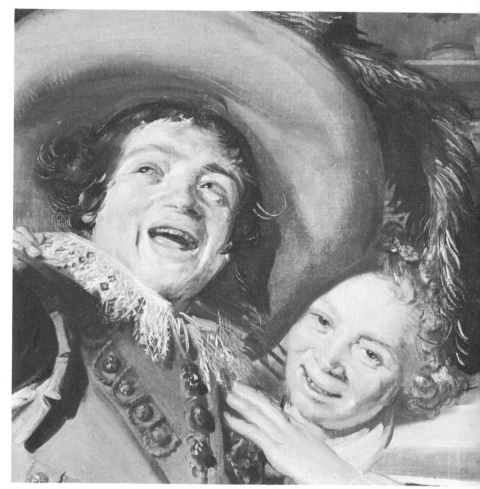

144

ADORATION OF THE MAGI
*Pen and bistre drawing
with wash*

Guercino (1591–1666)
*The Metropolitan Museum of
Art, Rogers Fund, 1908.*

In this spirited drawing, Guercino confirms with great simplicity that aging is not merely a matter of wrinkling, but also a change in structural forms. In the disparate age levels from the very young to the very old, infancy and youth are revealed in fullness of flesh and roundness of forms, while maturity and age are expressed in dryness of tissue and angularity of bony supports. The line only briefly makes a concession to a wrinkle here and there, but it is the wash tone which puts the compact volume of these heads in relief. And it is this use of massed form and plane that does the work of age characterization.

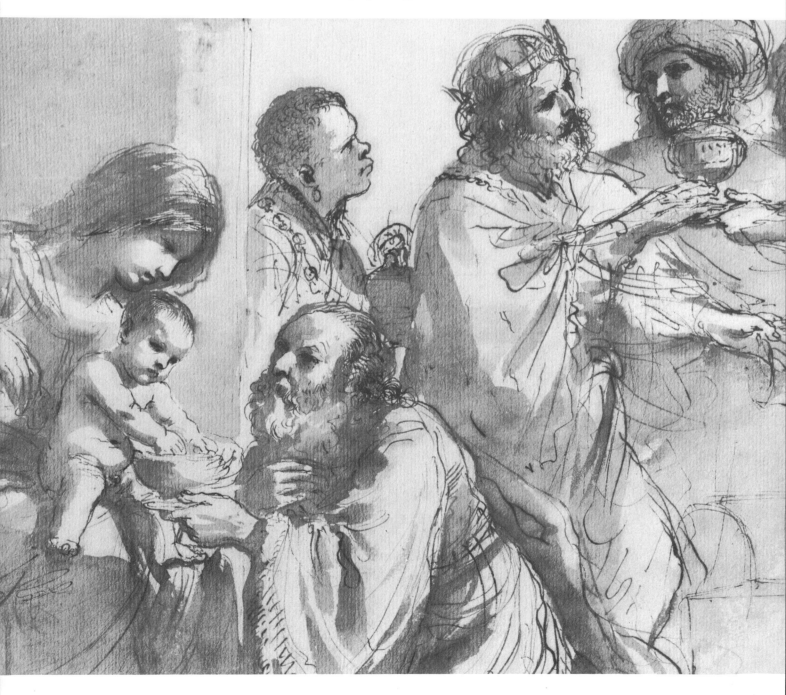

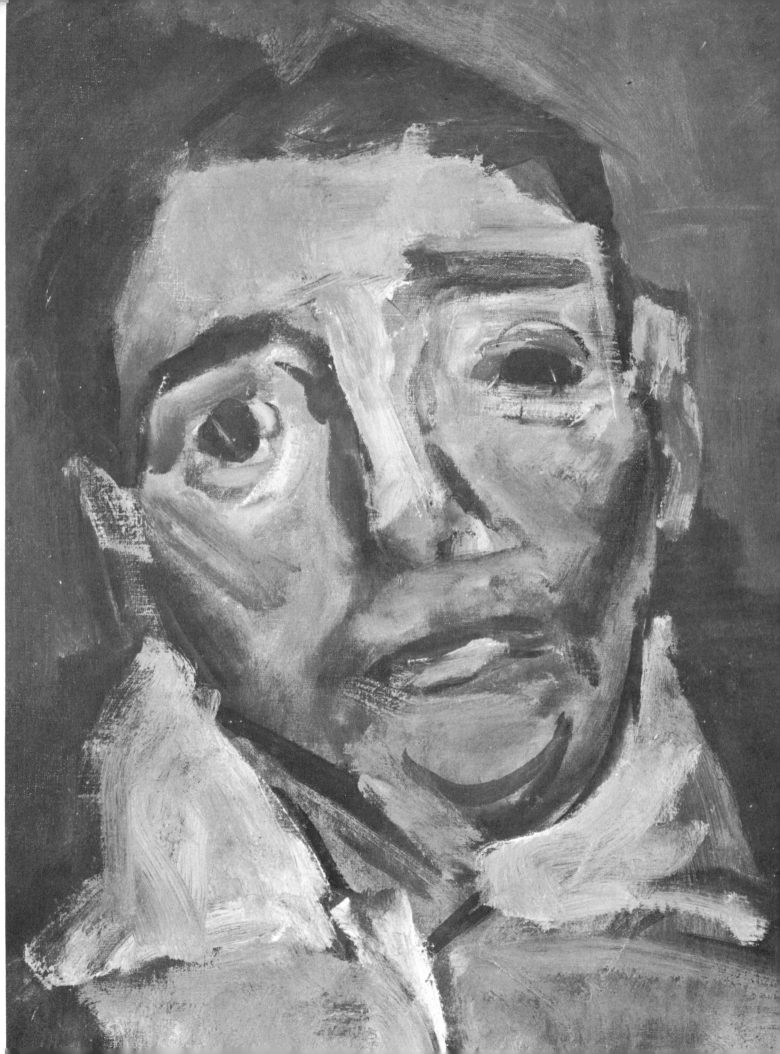

PORTRAIT OF HENRI LEBASQUE
(DETAIL)
Oil on canvas

Georges Rouault (1871–1958)

The Metropolitan Museum of Art, Purchase, 1951, Joseph Pulitzer Bequest.

When a Fauve painter like Rouault expresses a head in a tragic mood, the brush may slash and stab; but rough-hewn and raw as this head first appears, it still affirms a knowledge and mastery of forms. See how Rouault holds to the mouth bulge, the maxillaries over which the lips are scored, and the nose wedge, blocked and clipped. And however disparate the eyes, they relate to the socket position. Finally, the disposition of the ears, cheek bones, and facial planes confirm the artist's structural planning. The result is an underlying sense of order over which, as on a battlefield, a destructive struggle has taken place.

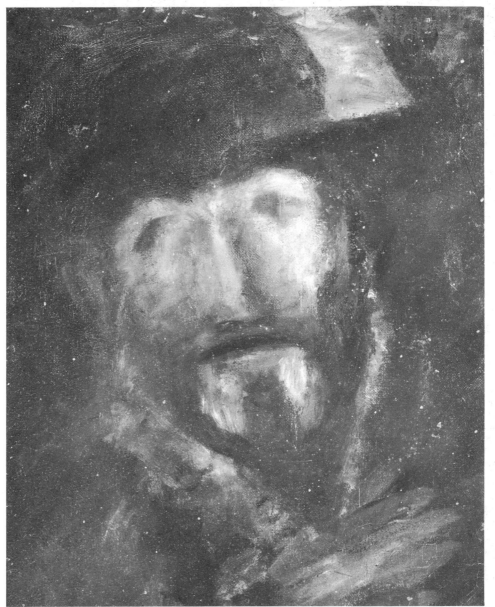

STUDY FOR HENRY IRVING
AS PHILIP II OF SPAIN
Oil on canvas

James Abbot McNeill Whistler
(1834–1903)

The Metropolitan Museum of Art, Gift of George S. Hellman, 1955.

At first glance, this seemingly rudimentary and unfinished painting projects an immaterial, amorphous quality. While the details may be vague, there is nevertheless a studied unity in the assemblage of masses. The light play, expressed in tonal recession, moves from the intense upper right of the hat and cheek plane to the lower left chin and jaw. Then the slash of the mouth, the nose base, the bearded chin, the touches of eyes and ears are affixed, and the whole is securely inserted into the collar and shoulders. The fleeting, nondescript impression is dispelled as the head takes on a plastic totality in space. The head solidly exists, though details are missing, as if veiled in an atmospheric haze.

BOY WITH A BASEBALL
(DETAIL)
Oil on canvas

George Benjamin Luks
(1867–1933)

The Metropolitan Museum of Art, Gift of Edward J. Gallagher, Jr., 1954.

This vigorous result is not a mere show of facility, but the product of self-confidence which comes from a vast surplus of knowledge. Against a tonal background, the brush plays on structures relieved in light which tugs at the cap, hair, cheek bones, nose, mouth, and jaw. Then lesser values cut back recesses and lateral planes until the structured masses evolve into a coherent whole. From here, the finish is a simple matter of abbreviated touches of pupils, nostrils, lips, chin, and hair accents.

▼

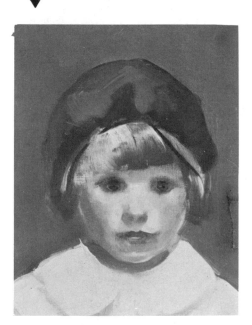

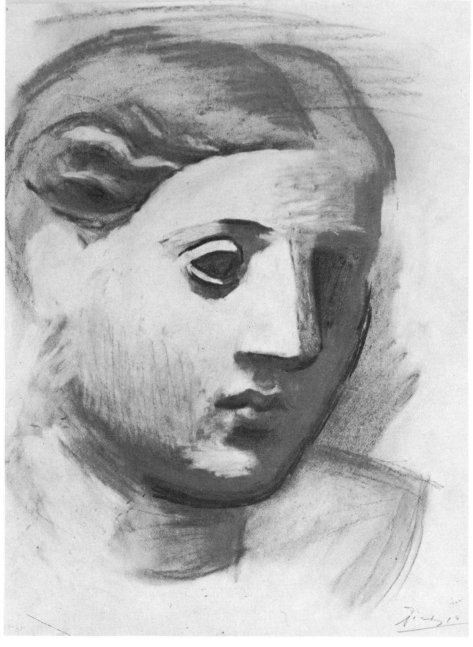

HEAD OF A WOMAN ▲
Chalk on paper

Pablo Picasso (born 1881)

The Metropolitan Museum of Art, Gift of Mr. and Mrs. Justin K. Thannhauser, 1950.

The suggestion of weight and bulk in the structured masses of the left side of the head contrast with the vaporous, unclarified mass of the right side. Although the artist draws in a rough-hewn manner which implies a conflict between the controlled and the chaotic, Picasso is never unsure of himself. His treatment may be crude, but his forms are always in order. First, he presents the ovoid head mass. Then he imbeds the eye under the brow, but carefully related to the edge of the nostril wing. The implied ear is correctly placed, as are the suave, soft mouth with the philtrum channel, and the well-formed cheek and side plane joining the chin.

STUDY FOR A PORTRAIT OF
EDOUARD MANET (DETAIL)
Lead pencil on paper
Edgar Degas (1834–1917)
*The Metropolitan Museum of
Art, Rogers Fund, 1918.*

A great draughtsman is at his best when he can, like Degas, use his vast knowledge to be subtle and suggestive when forms are modest and unimportant, and then assert swift, staccato accents at those crucial points where form becomes significant. In this portrait, a tentative, casual stroking is given to the wispy hair, mustache, and beard, while light flicks of the pencil barely tell of the brow, cheek, and nose planes. We scarcely realize that Degas is tempering the eye with the rapier-like touch of the pupils; incising the nose base, ear curves, and neck line; at the same time taking up the slack gray of the mustache and beard with the tensions of mouth and cheek. The result is deceptively effortless and disarming; yet underneath, how adroit and unequivocal are the means which produce it.

PORTRAIT OF
AMBROISE VOLLARD
Pencil on paper
Pablo Picasso (born 1881)
*The Metropolitan Museum of
Art, Elisha Whittelsey
Collection, 1947.*

The artist's approach seems dry, plodding, and parsimonious; not an elegant, virtuoso performance. But look at the personality Picasso has drawn: the humorless, intractable cast of the man. Picasso's slow, exacting line and form explain the character as well as the identity of the sitter. The artist digs out the obstinate set of the mouth over the stubborn jaw; the lips stretch to the left of the face, and to emphasize the pugnacious thrust, he grinds a tone under the right bearded jaw and cheek. He mounts the blunt nose over the lift of the dentures and takes in the pair of cold, aloof eyes. He delineates the large vault of the skull edged with the scrubby fringe of hair; the lackluster ear joined to the thick neck; and the whole of the head mass erected on the heavy, phlegmatic body. A pervasive gracelessness is suggested in the man *through* the art.

HEAD OF A MAN
Silverpoint
Alphonse Legros (1837–1911)
*The Metropolitan Museum of
Art, Gift of the Artist, 1892.*

In drawing a head, a problem not easily grasped is the fact that the over-all mass curves from top to bottom and from left to right. Legros explains this with a fine network of linear strokes, building great masses overlaid with smaller forms in consistent tonal recession. The distinction is shown in the gradual descent of the tones, using an overhead left light. As the facial plane curves from top to bottom, the value lowers and the forms sink slowly in depth. Only briefly does the nose emerge in light; but the lower lip and chin are progressively set downward, as are the upper and lower lids. The left-to-right curvature is governed by an increasing modulation of darks across the mounds of form until the side plane of the head is reached; then a general, almost uniform darkness obscures the right mass. Note the care with which forms are reduced in depth of plane without hard edges.

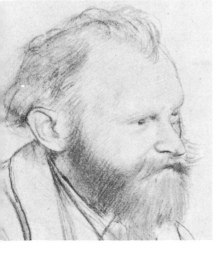

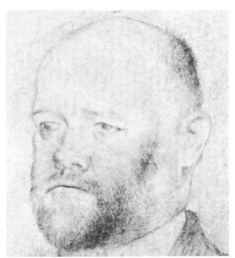

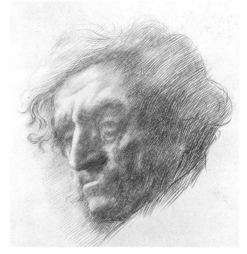

149

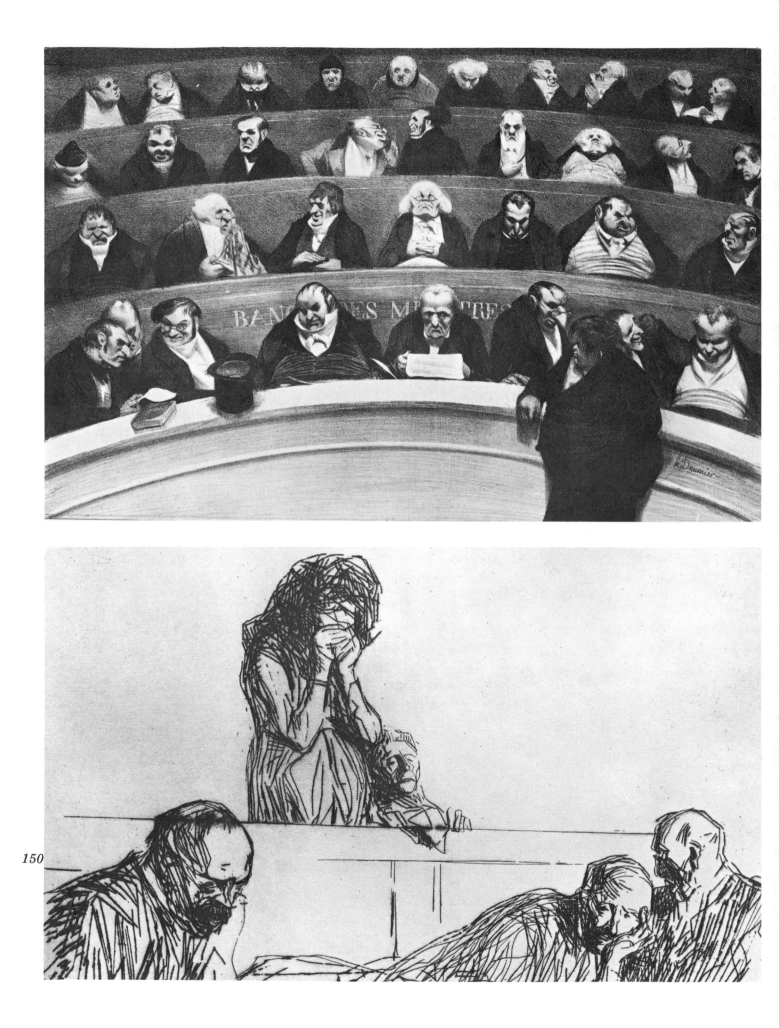

LE VENTRE LEGISLATIF
Lithograph
Honoré Daumier (1808–1879)
*The Metropolitan Museum of
Art, Rogers Fund, 1920.*

The art of caricature needs an exacting fund of information with which to play out the extremes of exaggeration and grotesquerie. In his gallery of rascals, knaves, and blackguards, Daumier is savage and vitriolic. But whatever his temper, he never lets his craft lose discrimination or self-possession. His art, though it renders the gross and obnoxious, cannot be incautious or careless. Treading close to absurdity, he is always scrupulous in his control of form. He provokes laughter at his victims while the artist goes unscathed.

LA FILLE-MÈRE (DETAIL)
Etching
Jean-Louis Forain
(1852–1931)
*The Metropolitan Museum of
Art, Rogers Fund, 1921.*

Terse, edged planes, massed with dark areas, are sufficient to establish an individual's identity. Forain's approach is sculptural in its simplicity. He holds to a continuity of facial structure, moving from crown to brow, cheek bone to jaw. His incisive edge and loosely stroked line give a documentary realism to his characterizations. As he shows with telling impact, exclusion of details need not disqualify an effective solution.

YEUX CLOS
Lithograph
Odilon Redon
*The Metropolitan Museum of
Art, Dick Fund, 1925.*

A vague half-light diffuses the entire left side of the head and implies a concealment of form. Ordinarily, such an ambiguous approach might lead to a feeble and inarticulate result. The right side, however, is given a more concentrated light, which exposes the lucid forms of the eye and socket structures, the nose and cheek planes, the mouth and jaw formations. Here and there, the line accents on lips, nostrils, eyes, and hair redeem the unified appearance of the head. Before the vaporous tone may have seemed neutral; now, with these accents of light and line, the shaded region takes on a mysterious, occult, poetic quality.

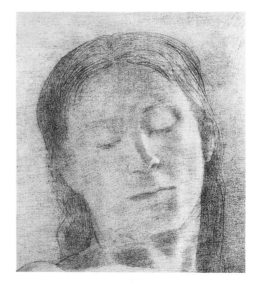

151

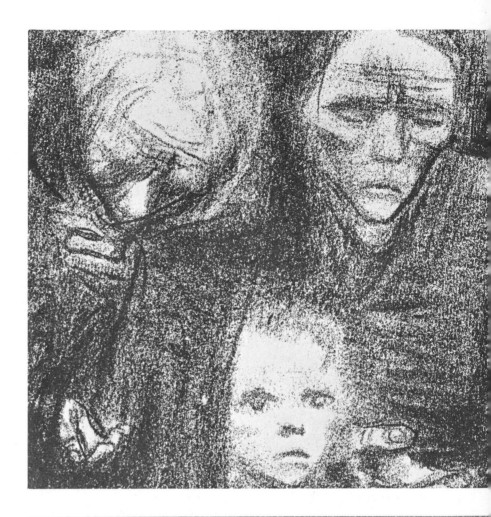

BEGGING
Lithograph
Kathe Kollwitz (1867–1945)
The Metropolitan Museum of Art, Dick Fund, 1928.

PORTRAIT OF HÉLÈNE BELLON
Oil on canvas
Pierre Auguste Renoir (1841–1919)
The Metropolitan Museum of Art, Gift of Miss G. Louise Robinson, 1940.

Sound structure in drawing always conveys respect and confidence in the intent of an artist, however specialized his intent may be. Between Renoir and Kollwitz the expressive results may stand diametrically opposed to one another. Kollwitz' withered distortion projects pathos; Renoir proclaims vitality. The arid, granulated line and tone of Kollwitz contrasts with the full-blown form and volume of Renoir. But whatever the artist's method of conveying his meaning, one fact is clear: the mastery of ordered form lies at the bottom of all good art.

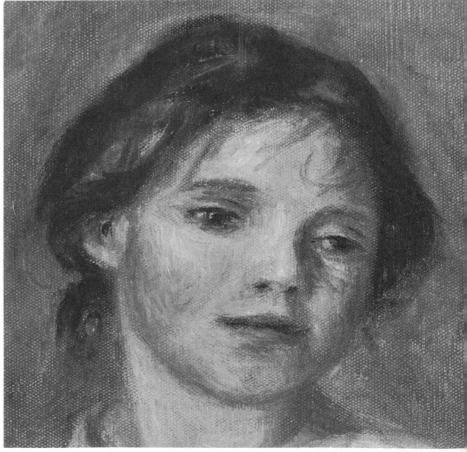

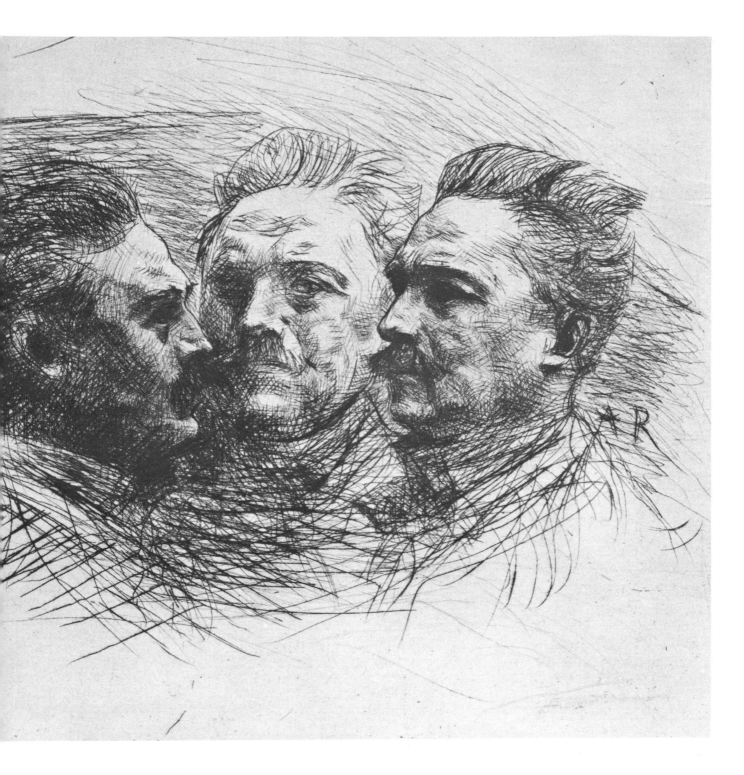

PORTRAIT OF HENRY BECQUE
Drypoint

Auguste Rodin (1840–1917)
The Metropolitan Museum of Art, Rogers Fund, 1922.

When a sculptor works out a graphic problem, his tendency is to render volumes in space by chiseling and carving with line. Rodin, using a top-light source on three views of his subject, lays bare sculpturesque planes; gouges and undercuts ledges of structure; delicately chips and scrapes lesser depressions. The overhead light is used as a tool to examine the relationships of forms to the variations of texture. The end result is decisive clarity.

153

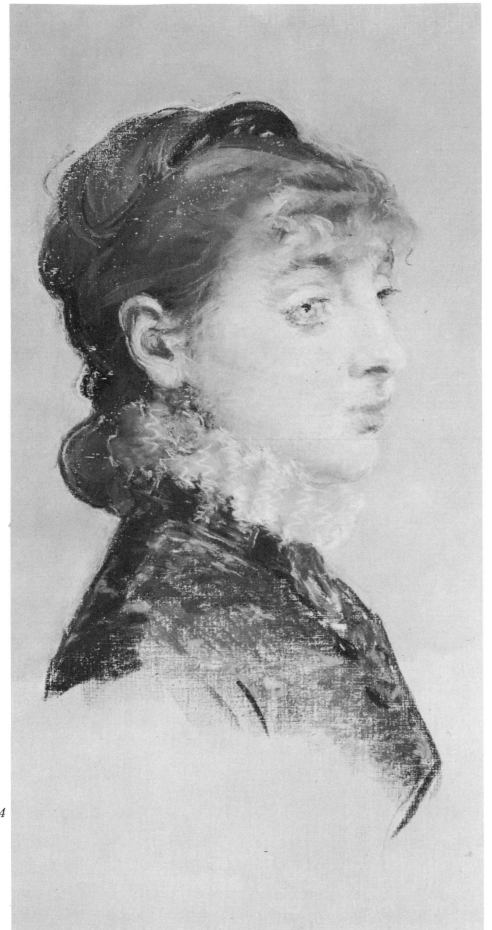

PORTRAIT OF MLLE. VALTESSE
DE LA BIGNE
Pastel on canvas

Edouard Manet (1832–1883)

*The Metropolitan Museum of
Art, Bequest of Mrs. H. O.
Havemeyer, 1929.*

As Rodin is a carver, Manet is
a painter. Light is used here
not to explain forms but to ex-
hibit the personality of the sit-
ter and to extol the sensuality
of materials. See how Manet
varies his stroke, from the
swaying rhythms of the hair
to the sensitive caress of the
flesh; from the delicate touches
of the features to the nimble
cadence of the ruff. The joy of
his line is as beguiling as the
plasticity of his surfaces. And
the correctness of his forms—
their placement, accenting,
and highlighting—matches the
charm of the sitter.

Index